Painting
in Oils

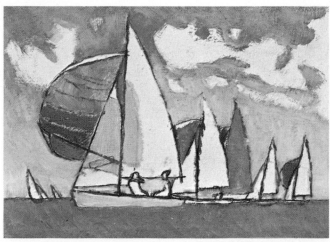

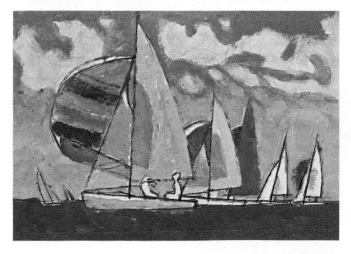

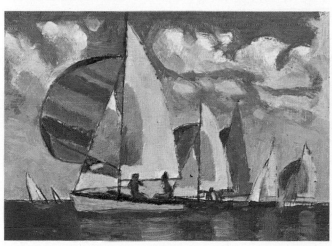

The Authors

Clifford Bayly trained at St Martin's and Camberwell Schools of Art. He has taught for many years in Kent and is head of the Department of Graphic Design at Maidstone College of Art. He is an associate member of the Royal Society of Painters in Watercolour. His work is exhibited regularly in the Royal Academy, the R.W.S. Bankside Gallery and other London and local galleries. His commissioned work can be found in Europe, America and Australasia. He lives in the Weald of Kent.

Norman Battershill lives in the Sussex countryside where he paints full time. He is a member of the Royal Society of British Artists, The Royal Institute of Oil Painters, the Pastel Society, and president of the Society of Sussex Painters and the Arun Art Society. He regularly contributes articles to *The Artist* and is author of a number of books on painting and drawing.

Peter Gilman, who was born in Surrey, is well-known as a lecturer on oil, watercolour and acrylic painting techniques, and a regular exhibitor at the Royal Society of Marine Artists exhibitions. He works mainly in Norfolk and Surrey and along the Thames, and has had many one-man shows. He now lives in Hertfordshire.

Dennis Frost trained at St Martin's and Putney Schools of Art. He paints about 1,500 portraits each year, exhibits at a few London galleries, at the Jonathan Miller Gallery, Carmel, California, and is a Council Member of the Pastel Society. He has also written, in the *Leisure Arts* series, a volume on PORTRAITS IN PASTEL.

Painting in Oils

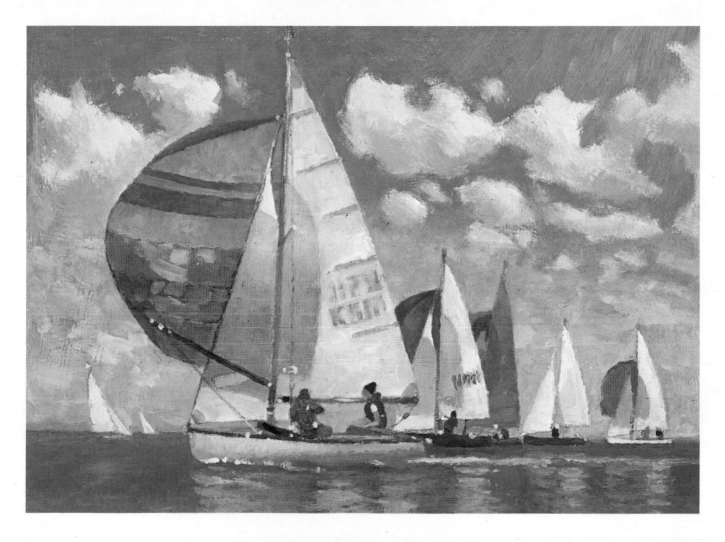

Norman Battershill Clifford Bayly
Dennis Frost Peter Gilman

PAN BOOKS
London & Sydney
in association with
SEARCH PRESS LTD
Tunbridge Wells

First published 1982

by Pan Books Ltd
Cavaye Place, London, SW10 9PG

and simultaneously by

Search Press Ltd
Wellwood, North Farm Road,
Tunbridge Wells, Kent, TN2 3DR

Reprinted 1986

Based on the following volumes of the Leisure Arts series first
published by Search Press, London and Tunbridge Wells;
Taplinger Publishing Co., Inc., New York; and Methuen of
Australia Pty Ltd, North Ryde, NSW

Working with oils by Norman Battershill
Painting Landscapes in oils by Norman Battershill
Painting Flowers in oils by Norman Battershill
Basic oil brushwork by Clifford Bayly
Painting Boats and Harbours in oils by Clifford Bayly
Painting Portraits in oils by Dennis Frost
Oil painting Outdoors by Peter Gilman

Edited by Michael Bowers
Design by David Stanley
© Search Press Ltd 1980, 1981, 1982
Front cover design © Norman Battershill 1982

Typeset by Studio ·918, Tunbridge Wells, Kent

Made and printed in Spain by A. G. Elkar, S. Coop.
Autonomía, 71-48012 Bilbao

ISBN 0–330–26675–6

Contents

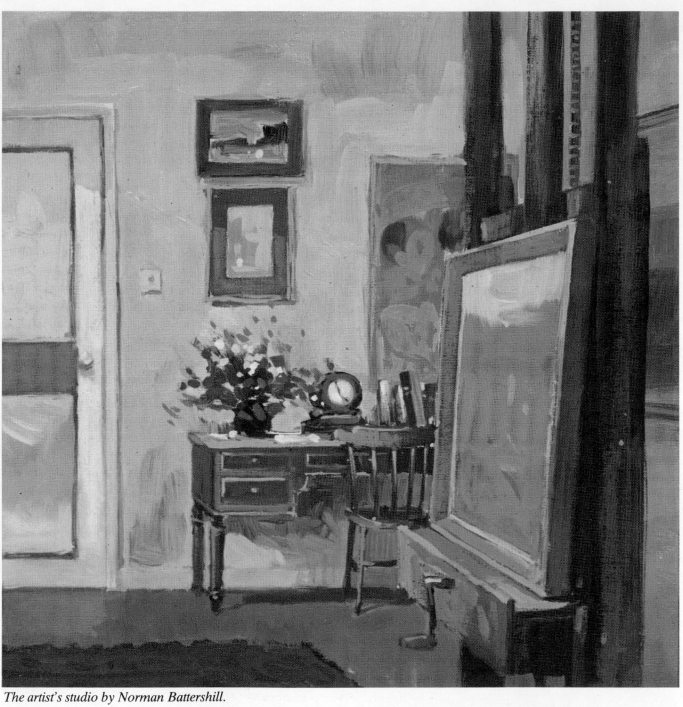

The artist's studio by Norman Battershill.

Introduction

Man has always enjoyed making marks. Most of us are familiar with prehistoric rock and cave paintings but even before then man was chipping marks and signs into stone and scratching lines into bones. This process of sign making was very extensive: far more than present evidence suggests for the majority of work of primitive man has been lost to us as it was made on perishable material, to say nothing of his drawings in the sand and scratching on surfaces which eroded rapidly away.

We have not changed essentially in our fascination with making pictures. Naturally our tools have become more sophisticated but they are basically the same as those used by artists and craftsmen several centuries ago, although modern technology and the development of plastics have given us the nylon polyester brush and acrylic paint. The process of picture making is, in the main, traditionally similar, and provides tremendous enjoyment and satisfaction for all of us who are prepared to spend some time practising and studying the subject.

Bear in mind that, however brilliant the artist becomes in the techniques of applying 'paint to canvas', these should not become an end in themselves. Sheer virtuosity can never replace content; it only constitutes the means by which to express your approach to the subject of your painting.

In the early stages do not invest in a large number of tools and materials. A modest range of basic items will suffice to start with; and this can be supplemented as your skill develops. It is a false economy to buy cheap tools. However, when practising techniques it is not always necessary to use expensive paints and canvas.

A good artist's suppliers' showroom is to me an Aladin's cave. I have never lost the enthusiasm and excitement I felt as a child when looking at boxes of paints and other 'goodies' in the local art shop. The sheer variety and visual quality of most of the items is endless: brushes of every shape and size, little pans of watercolour paint, large squashy seductive tubes of oil colour, bottles of various oils and varnishes from clear to dark brown, and smooth wooden or pristine white palettes. Appreciation of the basic qualities of materials in their own right is an essential part of any artist's attitude to his or her work.

How to use this book

Painting in Oils is a subject which offers no clearly defined route from a simple beginning to ultimate success. There are almost as many schools of thought as there are painters; as many methods as there are tools to apply them. Even so, it is clear that those who aim to paint in oils must, and will, find a path which suits their requirements and ambitions. This book has been devised to smooth the painter's progress without restricting his approach.

A substantial part of the book is devoted to the fundamental skills of brushwork – the platform upon which every painter builds his own style and method.

Landscape painting also receives considerable attention. This is a subject which has absorbed painters since very early times and which embraces the widest possible variation in content. The step-by-step demonstrations in this section, and indeed throughout the book, provide a very clear link between the explanation of techniques and the business of painting pictures.

Later in the book, subjects of more specialised interests – portraits, flowers and boats – are given a similar step-by-step treatment.

Do not be afraid to follow the demonstrations very closely in the early stages of your own work. This will help you to gain confidence in your own skills and you will soon learn to adapt and modify as you develop your style and approach.

Tools and Equipment
by Clifford Bayly, Norman Battershill and Peter Gilman

Brushes

The brush is the basic tool of the painter. It is essential from the start to work with good quality brushes. Cheap badly-made ones will only give poor results and dissatisfaction. Good brushes are a pleasure to work with and will last far longer.

Take a well-made brush and just look at it. Finely shaped handle, clean bright ferrule and silky springy bristles. Hold it, feel the 'balance', check the soft resilient bristles. Does it not make you impatient to get painting? A well-made brush is a beautiful object in its own right.

Brushwork is not produced by the brush but by the painter using the brush. This may seem obvious yet it underlines the fact that any tool is only an extension of our hand and thoughts. Its marks will reflect our approach to our work. Brush strokes also demonstrate the character of the painter. Short nervous jabs, long langorous sweeps, dynamic swirling rhythms, all describe different reactions and approaches to the subject.

Here and on the next pages we have prepared a short practical description of most of the brushes normally required for most paintings. The illustrations are intended as an identification parade for reference throughout the book.

Although the wide choice of shape, size, quality and price of brushes can be daunting, do not despair. Their various functions will become evident as you progress through the book and you will find it comparatively simple to decide eventually which ones you need. Start, though, with a modest range of sizes, say 2, 3, 5, 7 and 10 in flat or filbert hog-hair bristle, a size 8 flat sable and sable rigger size 3.

A fan brush is not necessary to begin with but useful when you have developed more confidence.

Hog-hair and bristle

Bristles should be set in the brush so that the natural taper is with the finer end towards the tip and the natural bend curved in toward the centre of the brush. This prevents splaying. Shorter bristles are for use with thick paint.

Filberts are flat in section: the pointed end is useful when drawing in or working on smaller forms.

The fan brush is for blending colour after it has been applied with normal brushes: sky, foliage, and for hair in portraiture.

House-painting style brushes are useful for applying primer and grounds to board or canvas. The varnish brush is thinner in section to cover areas smoothly and has long bristles to give a soft and flexible touch.

Sable, nylon and polyester

Long sable brushes are for fine work, round section or riggers for lines, fans for blending.

Synthetic fibres are hard-wearing and are used mainly for acrylic painting.

Polyester fibres are the nearest to bristle and are less expensive, but I would only recommend them for oil painting after one has acquired confidence in the use of bristle brushes.

Palette knives and mahl stick

Cranked painting knives supplement our brushwork. Since paint is applied in strokes or flat slabs, they add physical texture to the surface of a painting. Their use is only recommended after you reach a fair degree of competence with brushes.

The palette knife is used for mixing large amounts of paint on the palette to avoid wear on brushes and for scraping off surplus paint.

The mahl stick has a padded top which is rested against the side edge of the painting when supporting the working hand to put in fine work on a wet surface.

Palette

The traditional wooden palette comes in a choice of three shapes, oval, kidney or oblong. Melamine palettes are also popular. Whichever you prefer, the most important thing is that the palette should feel comfortable to hold. Rub linseed oil into a new wooden palette before using it, as otherwise it will soak up the oil from the paint. Tear-off paper palettes are convenient and practical, especially for outdoor work.

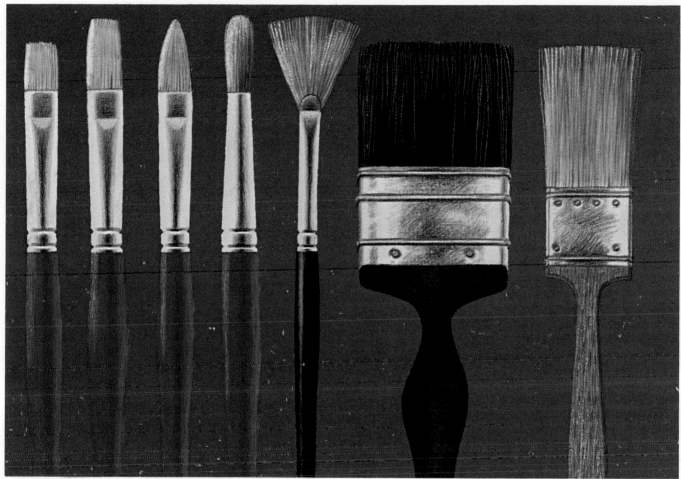

Left to right: Short bristle, long , bristle filbert, round, fan, house-painting style brush, varnishing brush.

Dippers

Dippers are metal cups that clip on to the palette to hold turpentine and medium. They are available singly or in pairs and in different sizes, sometimes even with brass screw lids. A deep cup is preferable to a flat wide cup because it does not spill the contents so easily. They are ideal for painting outdoors.

Easel

To work out-of-doors, buy the best easel you can afford. The folding sketching type is ideal. Light to carry, easy to erect, it has the minimum of adjusting wing nuts and you can push the legs into soft ground which makes it very stable; otherwise, in windy conditions, hang your bag or a slung brick from the stem. Keep a strong piece of cord tied to the stem of your easel in case of accidents! Once a year, on a fine day, brush on to it a coat of boiled linseed oil, in order to keep all the moving parts free.

Paint boxes and bags

A variety of light and easy-to-carry bags can be bought from Government Surplus Stores at low cost. Most artists' suppliers have bags designed for the artist with shoulder straps. When painting *in situ* ease of movement should be a priority consideration.

Many boxes are available – make your own choice: a pochade box is especially useful for quick sketching.

Grounds and supports

There are many: the most preferred (and the most expensive) is oil-primed canvas on stretchers. Many artists will use nothing else. However, acrylics give some very good grounds and some artists prepare their own on board or canvas with an acrylic paint.

Ready-made boards for oils are widely popular, as is hardboard (masonite) with the smooth side primed with acrylic primer.

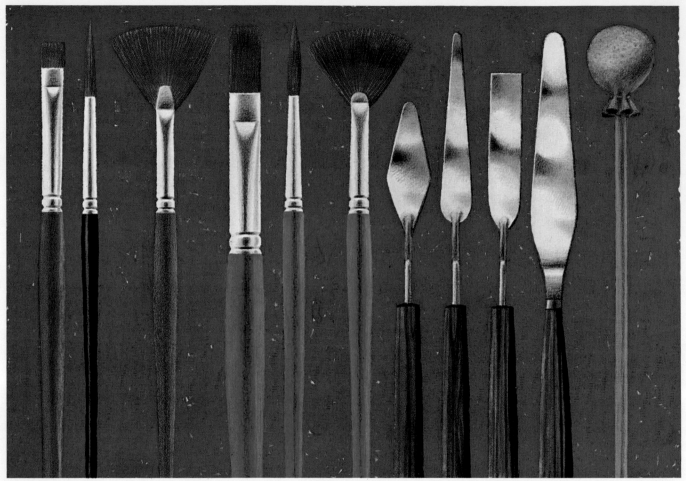

Flat, rigger and fan sable; flat, rigger and fan nylon; painting knives, palette knife, mahl stick.

Maintenance

To keep brushes, tools and materials in first-class condition it is important to allow sufficient time for cleaning and checking. Tools and materials deteriorate rapidly if neglected. Working with badly maintained equipment is frustrating and misleading as results are inevitably disappointing. Renewal is expensive and wasteful, to say nothing of the bad working habits that can develop in consequence.

After use, clean your brushes with plenty of turpentine substitute and clean rag or tissue, paying particular attention to the base of bristles. Massage bristles in the palm of the hand with soap and warm water, rinse, repeat this soap and water washing until a rich lather develops, then give a final rinse. Gently squeeze out any surplus water and lay the brush flat to dry. Brushes can be kept bristle-up in a jar or stored flat in a drawer or tray. Ferrules and handles should be kept clean and polished. Sables should receive very careful handling when washing.

When using acrylic primer for grounds, wash the brush very thoroughly in water immediately after use.

Palette and painting knives should be kept clean with turpentine substitute and polished thoroughly after use. Do not scrape, or use abrasive cleaners. If you have used acrylic paint with a painting knife, wash it with water but dry it immediately as the blade may rust. Keep handles clean and polished.

If you find a particular brush is deteriorating, do not throw it away, keep it for rough work, such as blocking in when you start or for a rough scrubby textured area in a painting. This can help to prolong the life of the other brushes.

Clean the palette with turpentine after each painting session. If you are using a wooden palette rub a little linseed oil into the surface after cleaning.

Let your painting dry thoroughly before varnishing. It is normal to wait several weeks before you varnish; during this period keep the painting in a vertical position so that it does not attract dust and protect it from direct sunlight.

Preparing to paint

Commentary and demonstration by
Clifford Bayly

Grounds and underpainting

Your board or canvas surface can have a direct effect upon the final appearance of your painting. Most painters prefer a textured surface. With prepared canvas this exists already and is known as the 'tooth' – coarse or fine according to thickness of the thread and the way it is woven. Canvas-textured and smooth boards already prepared can be bought and are cheaper than prepared canvas: preparing your own boards is cheapest of all.

Giving yourself a strong tooth on which to work can help you understand more fully the possibilities that exist in oil painting. Naturally the degree of texture should be related to the size of the painting surface and the subject-matter. A strong texture should not normally be used on small panels or canvases.

I shall confine myself to describing the priming of hardboard panels, as they are the cheapest and most easily obtained supports for oil painting, and do not need a back frame or stretcher.

Cover your surface evenly and thinly with one coat of emulsion-acrylic primer and let this dry thoroughly. Now apply one or more further coats of primer or ground to achieve your required texture. If you want a very smooth final effect in your painting, try to eliminate brush marks by painting the second coat crosswise against the first, then rub down with fine glasspaper when the paint is dry and hardened.

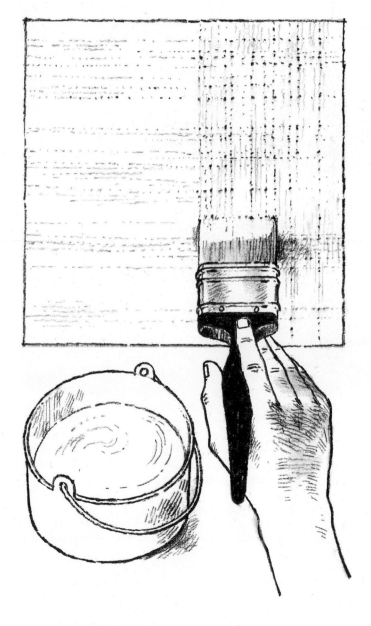

Materials

The textures illustrated on this page were applied to hardboard, but one can practise them on primed paper or card, satisfactory and economical supports, but which have little permanence.

The ground textures illustrated here are all basic and easy to achieve.

a. This consists of one or more coats laid down with the brush strokes running in one direction. A coarse bristle brush will give strong texture and a softer brush a smoother finish. This fact applies to any texture you may produce.

b. For a canvas-like base apply your second coat of ground and any subsequent coats in the opposite direction to the previous coat leaving each application to dry before beginning the next.

Textures a. and b. both give a static quality to the ultimate effect of the painting.

c. For a painting in which the subject demands a vigorous effect or where movement is an important element it can be helpful to produce a ground texture which has a strong feeling of movement itself. This is achieved by swirling or twisting brush strokes running counter to each other so that the effect is uniform over the panel but still contains movement and excitement.

d. Stronger textures can be produced by other tools than the brush. After a first coat of ground has dried, the second should be applied generously and allowed to dry a little before texturing, using a pointed stick or brush handle.

Care and discretion should be exercised in producing such textures as they can easily become too strong for the subsequent painting; but practise and experiment!

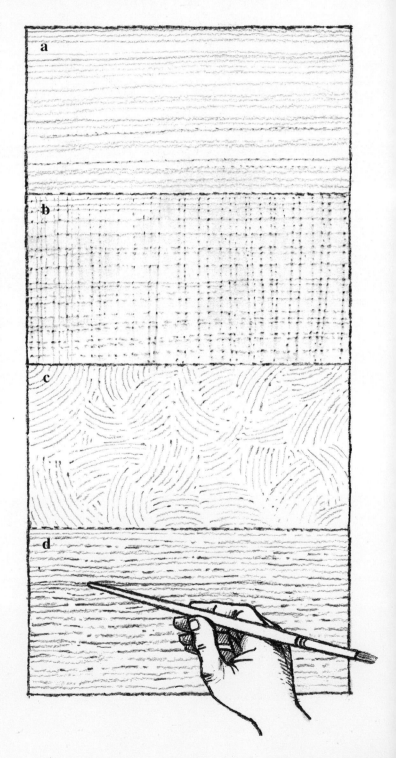

Stage 1

Stage 2

Demonstration

This painting (on the next page) features the qualities of varnished boards and other wood forms against sky and beach. I therefore chose as the most appropriate ground example *c.* on the opposite page.

Stage 1

I drew in the main forms using a dark neutral colour, in this case raw umber mixed with a little permanent blue and white. I first tried out the effect of the ground brush texture by rubbing ochre lightly over the surface. This was not quite what I wanted so I then decided to scumble the surface – that is, to paint solidly over the area and then to wipe or scrape away the surface paint, leaving a residue in the hollows of the ground texture. This simple technique allows the original ground brushwork to show to maximum advantage.

Stage 2

Having tried out these two methods of achieving a particular effect I was then able to block in all the main areas of the painting, simultaneously producing something of the quality of the varnished wood of the boat by wiping off surplus paint.

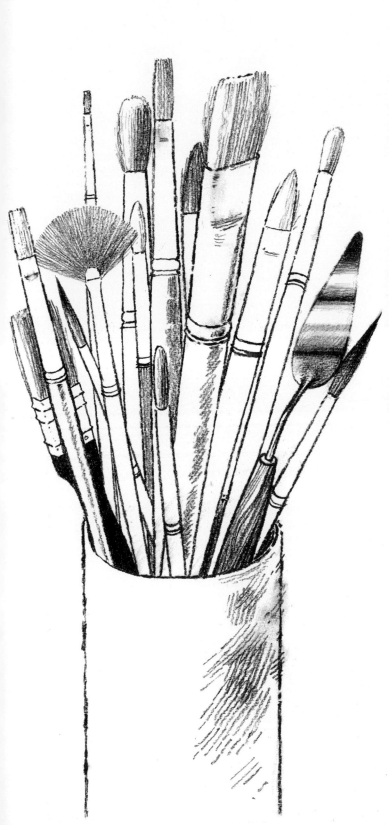

Some of the artist's own tools.

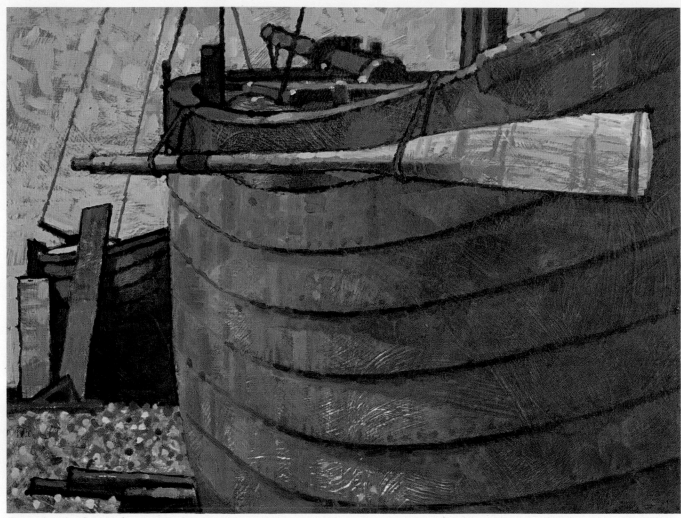

Stage 3 – the finished painting

Stage 3 – the finished painting

By further application of stronger colour mixed with turpentine and a little picture varnish to give more transparency, I was able to build up the final effect of the varnished wood. It was then necessary to use normal brushwork on areas such as the sky and the side of the boat where it reflected the cool light of the sky. The beach area was painted with a small flat sable varying the colour and tone of each short stroke to build a texture of pebbles.

In this demonstration it is the ground that has given it its textural quality and shows how you can, by thinking beforehand about the blank surface texture you wish to paint on, enhance the final result.

Check list

The following list of basic tools and materials will help to keep your experiments simple yet fully practical. (See the illustrations on pages 9 and 10.)

Flat hog-hair, short bristle, sizes 5 and 7
Flat hog-hair, long bristle, sizes 2, 5 and 10

Round hog-hair, long bristle, sizes 3, 5 and 10
Flat sable, long handle, size 3
Fan, hog-hair for later use, size 4
Filbert, hog-hair for drawing and detail, sizes 3 and 5
House painting brush for grounds, size 1½″ or 2″
Varnish brush (optional, as large flat hog-hair can be used)
Palette knife, 4″ blade
Painting knife, narrow trowel shape
A mahl stick is not really necessary but if required can easily be made by padding the end of a piece of cane or dowel rod of about 1 cm or ⅜″ diameter and between 45 cm and 60 cm, 18″ and 24″ long
Hardboard: panels ranging from 15 cm × 24 cm, or 6″ × 8″, to approximately 45 cm × 60 cm, or 18″ × 24″
Turpentine or turpentine substitute
Raw linseed oil
Picture varnish
White acrylic primer for boards

Colour mixing

by Norman Battershill

Be methodical in your colour mixing. Haphazard mixing will only result in muddiness. It is best to start with three or four colours, then add one or two more as you gain experience. Adding white to a colour produces a tint. Adding black produces a shade. Just three colours, plus black and white, will produce a wide range of tints and shades.

Try the following to begin with:

Basic palette

1. Cadmium red
2. Cadmium yellow pale
3. Ultramarine
4. White

Colour mix

1. Cadmium red with cadmium yellow and white
2. Ultramarine with cadmium yellow and white
3. Cadmium red with ultramarine and white

Start with white and add touches of each colour. When you have tried out the three colour mixes take a clean brush and some cadmium red. Experiment by adding white in increasing quantities: you will create a lovely range of strong and pale tints. Now mix white with the other two colours. If you add just a touch of black many more permutations are possible. But be careful with black, it very quickly reduces any bright colour to a dull muddiness.

Cadmium red, cadmium yellow and ultramarine.

Cadmium red with cadmium yellow = orange.

Cadmium yellow with ultramarine = green.

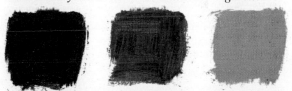

Cadmium red with ultramarine and white = mauve.

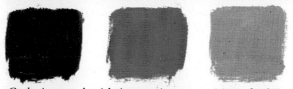

Cadmium red with increasing quantities of white.

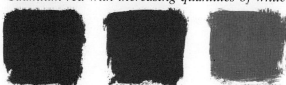

Cadmium yellow with increasing quantities of white.

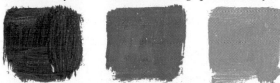

Ultramarine with increasing quantities of white.

15

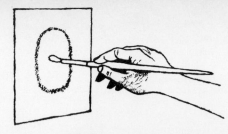

Basic Techniques
by Clifford Bayly

Brush control

After grounds and underpainting it is logical to consider the problems in producing finished brushwork.

Holding the brush

There is no single way of holding a brush other than the way when you apply the paint-loaded bristles to the picture surface and the mark they leave is exactly the one you wished to make! However, the three illustrations on this page give you an idea of the reasons behind the grips shown which are among the most commonly used by practising artists. Remember the brush itself is inert: it is your fingers, hand, wrist and arm up to the shoulder that control it. Any grip that restricts the appropriate mark from being made is obviously wrong: only practice will enable you to hold your brush without apparently being conscious of it so that the result accords with your intention.

a. This way of holding the brush is probably the most natural as it is the way most of us hold a pen or pencil. Although natural, it allows only a limited area of control. Within this area, however, we are able to paint quite fine detail.

b. This is the most widely used method of holding the brush. In fact the hand readily takes up this position when working broadly, particulary on large areas where a reasonable degree of control can be sustained over a wide area.

c. This grip is a compromise. It ensures quite a high degree of control over detail but is not so cramped as in example *a*. and sustains control over a fairly wide area. It enables you to work at a good distance from the surface, keep a light touch to your brush strokes and yet control the tip of the brush almost as well as in example *a*.

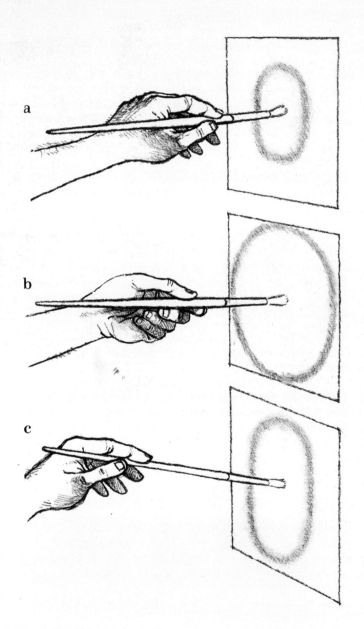

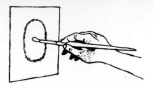

Stage 1

Demonstration

This shows how the character of the brush stroke helps to influence the total effect of the painting.

As this subject is essentially cool in colour – blues, grey and greens – I decided to use a complementary or opposite-coloured ground, perhaps a rather odd way to proceed, but by keeping my brush strokes slightly separated from each other and letting the warmth of the ground colour glint through here and there a scintillating effect is obtained which will vitalise the finished painting in a simple yet subtle way.

Stage 1

I covered the ground with a strong warm red; cadmium red hue and yellow ochre thinned considerably with turpentine. When dry I indicated the main forms simply with raw umber, allowing my lines to become quite thick.

Stage 2

When blocking in I applied brush strokes lightly in colour thinned with turpentine, in order to cover the whole of the painting as quickly as possible with something of the final colour qualities. This is preferable to completing bits here and there while still leaving areas of the uncompromising red ground which would make it difficult to retain unity in the picture. I kept the brush strokes well separated from each other and short when beginning to cover the original drawing lines.

Stage 2

Stage 3

Having established a unified image, I now built up my colour more accurately, still keeping my brush strokes simple, short and separate. These enable the ground colour to glint through and prevent the paint from building up and becoming slimy. Remember to keep an eye on the tone values while mixing colour – tone being the degree to which a colour is dark or light.

Stage 3

17

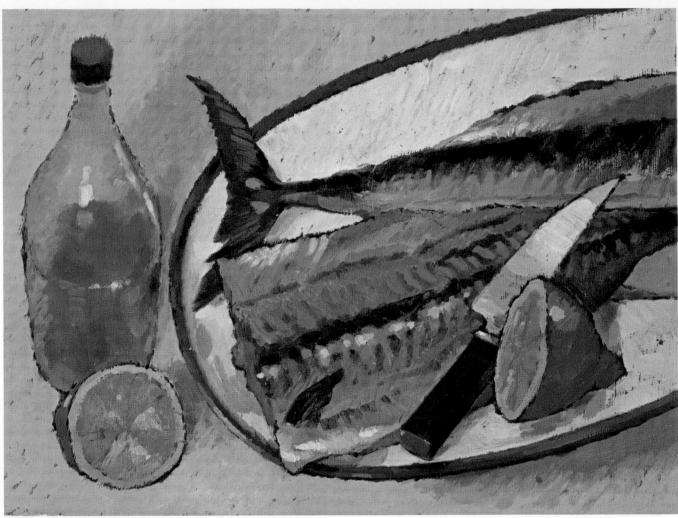

Stage 4 – the finished painting

Stage 4

There can now be more attention to detail, the painting of which must not be smaller in scale than the size of the average brush mark already used. If this were to happen the detail would appear not to belong to the painting and by comparison the previous brush marks would appear crude and heavy.

I made final adjustments to tone and colour while again taking care not to fill in between brush marks and at the edges of forms where little flashes of ground colour were permitted to glow through; for these give crispness and sparkle to the painting.

When using open loose brushwork like this, it is advisable to keep a certain grain or general direction to these strokes. As I am right-handed the natural direction for this grain runs diagonally from top right to left bottom or upwards along the same axis.

Palette knife

Its name suggests one of its functions, which is to mix paint in quantity on the palette by working colours together using a circular spreading movement. It is not advisable to use a brush for this as it twists the bristles and causes rapid wear.

Using the palette knife on the painting surface by scraping carefully in broad strokes will remove most of the paint already applied yet leave sufficient to retain the image. The resulting surface is pleasant to work into and quite a few artists use this technique very effectively.

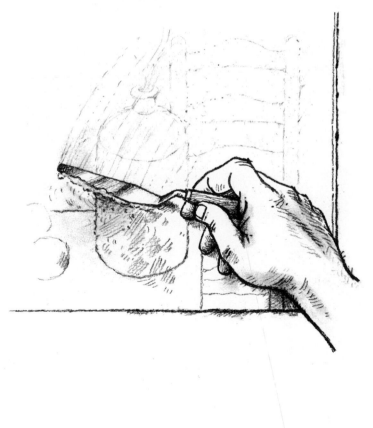

Medium and technique

Different painting materials strongly affect our brush-work and consequently the general appearance of a painting.

First, the consistency of the paint, which is the painting medium itself. For clarity I am confining myself here to linseed oil, turpentine and varnish.

Paint consistency directly influences our brushwork. When, for example, blocking or scrubbing in large areas at the start of a painting it is best to thin down the paint with turpentine and to use a round section hog-hair brush of good size.

When painting forms requiring simple flat areas of paint, it is advisable to use somewhat thicker paint by mixing with it only a little turpentine and adding a small amount of linseed oil. Use a flat hog-hair bristle brush and lay the paint on with short clean strokes. Do not smear it or stir it about. Freshness of colour and depth of tone are always impaired if the paint is disturbed too much after it has been laid down.

In areas of painting in which it is necessary to reduce the effect of brush strokes – such as clear skies, soft surfaces, hair and fur – it is helpful to keep the paint wet for a longer period than normal. This is achieved by mixing the paint with linseed oil only and then blending the brush strokes together with a clean soft sable brush or a fan brush specially made for this purpose.

To render texture, try dragging the brush across the surface of the board or canvas to give a fine broken effect. This requires a dry sticky paint consistency; it is best to use paint or mixtures straight from the tubes without adding turpentine or oil medium.

This technique deals only with the effect of painting consistency on brushwork. The demonstration which follows on the next two pages is a 'samplet' which shows some of the effects of materials on brushwork. Normally one would not use such a variety of techniques in one painting as it is difficult to retain unity and consistency, and objects are inclined to jump out of context. The demonstration should not, therefore, be looked at as a single painting but as a collection of samples put together for convenience.

Brushwork demonstration

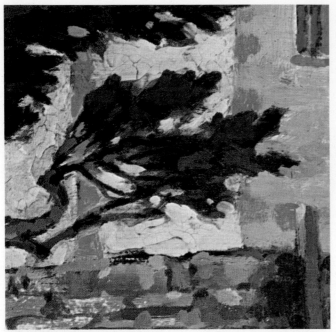

Detail 1

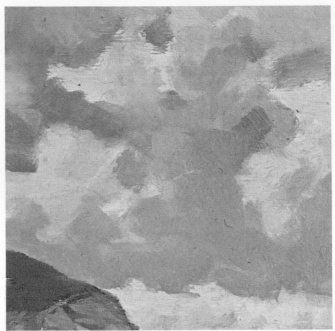

Detail 2

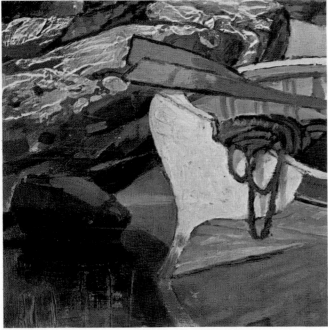

Detail 3

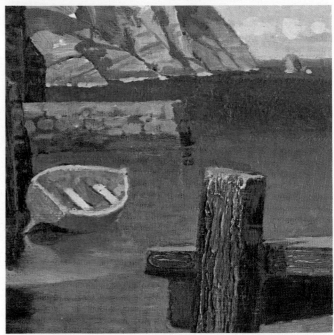

Detail 4

Detail 1

Here we have three simple techniques in which the amount and type of medium plays a part.

The foliage is painted with short brush strokes, laid on in the direction of the growth of the tree, using a small round sable brush and paint given a creamy consistency by adding a litle oil and turpentine in about equal quantities.

The sunlit wall surface of the house is achieved by scumbling – using thick paint applied with a painting knife which is then left until quite dry (several days in this case), and brushed over with a creamy brown oil

colour thinned with turpentine and then wiped clear of the higher surface leaving a residue in the hollows to emphasise the texture. The other wall in cool shadow is painted in the normal way using a small flat sable brush.

The stone jetty is painted similarly with a slightly thicker paint consistency with enables me to drag the brush here and there to produce a fine broken texture.

Detail 2

This is an example of fairly coarse brushwork where some blending and softening has been used to give a

20

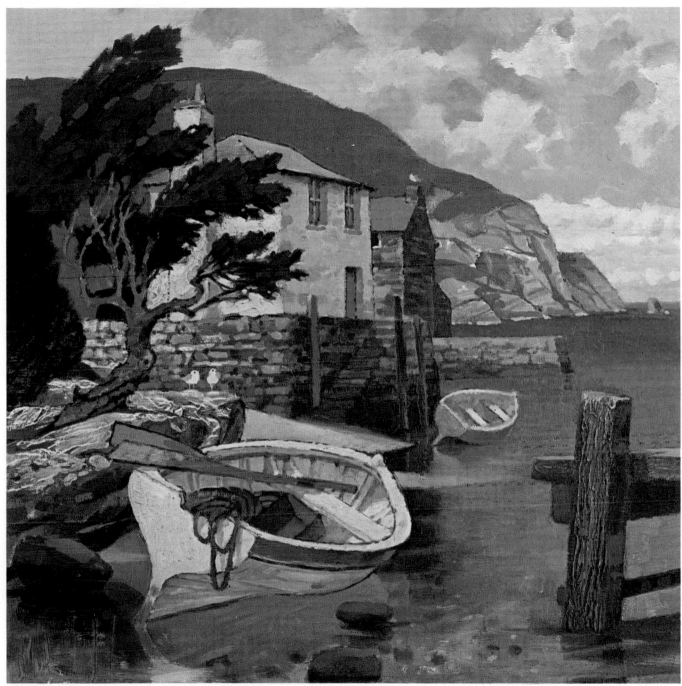

The finished painting

smooth gradation from one colour into another and produce a breezy animated effect. I used a flat hog-hair bristle No. 4 and produced the blending by using a similar clean bristle brush lightly drawn across the paint surface.

The paint was mixed with a little turpentine and oil.

Detail 3

Another example of scumbling – using the painting knife for the rocks and the boat.

The process of building up the underlying layer of paint is known as *impasto*. The soft reflections are a combination of slightly softened brush strokes and dry colour dragged across once the lower layers have dried.

Detail 4

An example of impasto where a wood-like texture has been achieved by scoring the original under-layer with a brush handle tip before scumbling with a dark brown. This texture is emphasised by the smoother painting of the sea in the background, which was achieved with paint mixed with oil and turpentine and a round long-haired bristle brush, No. 2.

21

Dynamic brushwork

Here we consider brushwork which is largely direc-
tional. The brush strokes follow the contours of the
forms or run over them in such a way as to assist the
drawing by adding solidity and structure.

When choosing to practise this form of brushwork
consider it carefully in relation to the subject-matter
and the composition of the painting. It emphasises
movement and rhythm and is particularly suitable for
paintings in which there are strong directional lines as
with rolling downland, trees blowing in the wind, fire,
clouds, animals and figures in movement.

When painting with this technique great care should
be taken to keep the paint fresh by not churning it up on
the surface of the painting as you work.

It is advisable to mix colour carefully on the palette
and then place it on your work very positively – that is,
lay the stroke on and leave it. Do not mix and blend
on the picture surface or you will find that the paint
becomes muddy and dull.

You can use short strokes, dabs or long strokes but
remember that the brushwork must remain secondary to
the purpose of the painting – not attracting too much
attention to itself at the expense of the subject-matter.

It is worth practising this technique on a very simple
subject such as a plant in a pot or a small growing shrub,
where strong lines of growth are rather pronounced.

To illustrate this approach to painting I have produced
a simple diagram showing the direction of the brush
strokes of the small painting on the opposite page in
which smoke and flames play a prominent part.

The stronger the brushwork the thicker the paint; con-
sequently one must expect to use far more paint and
medium in this technique. It is possible to under-paint
with thick acrylic/emulsion, building up strong strokes
and textural effects and then work over this with oil paint
later when dry, but it is best to practise these brush
strokes directly.

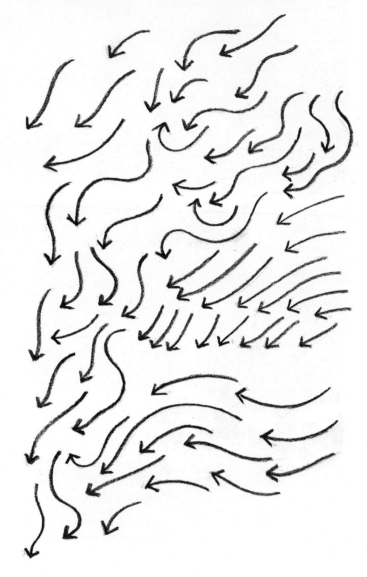

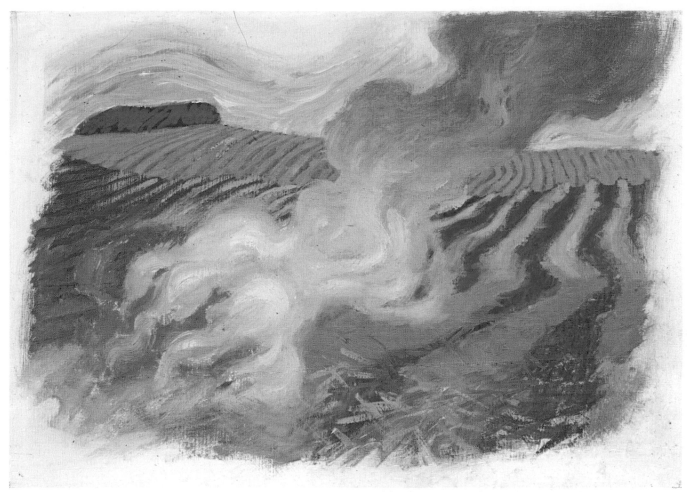

In this simple example the directions of the brush strokes have a similar quality to the lines in the landscape. This assists in keeping the picture unified and relates the brushwork to the subject matter.
The distant field has been kept simple and would need considerable attention if this painting were to be completed.

Demonstration

These demonstration paintings on this and the next page have purposely been left incomplete. By this means I show more clearly the way in which the brush strokes also help to draw the subject-matter.

I have emphasised the contours of some of the pictorial elements, possibly over-simplifying them, but this type of brushwork tends slightly to formalise objects, and to dramatise the subject-matter. This is so in the painting of the sky and fields with their swirling lines of burnt straw.

In painting the smoke, I carefully observed the forms which occur and decided to use long swirling strokes of the brush to show these to advantage. For this type of stroke I chose a round hog-hair brush and, using the paint thickly and generously, worked several tones together, being careful not to overwork the mixing on the surface of the painting. In fact I waited for my first strokes to dry and then went back over them adding extra emphasis to the lighter areas. By this means I was able to avoid the muddiness referred to earlier. An interesting visual effect possibly worth noting here is the cold blueish colour that smoke assumes when seen against a darker landscape. This however turns to a warm brownish hue when the smoke is silhouetted against a light surface such as the sky.

In the other painting, on page 24, I have picked out more definite subjects, less atmospheric than smoke and fire.

The swirling water gives another example of long animated brush strokes. The tree is somewhat different, and although the shape is rather sinuous the brush strokes need to suggest the texture of bark and I have

23

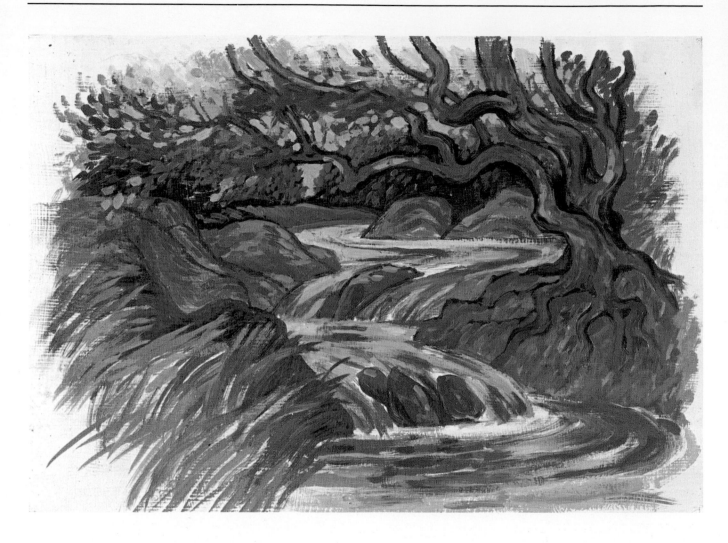

kept them short but have still followed the rhythm of the growth lines. This is also the case with the grass in the foreground, as it is drawn by the brush strokes themselves.

I have over-emphasised the quality of unity by keeping to very similar colours throughout, because I wished to draw attention mainly to the form and direction of the brushwork.

The simplification of shapes is also evident, and contours are emphasised by the painted outline – in some cases left from the original drawing-in guidelines.

There is an affinity between all the elements in this painting. The pattern of growth and strong directional lines in the water combine to give a sense of rhythm and movement which is characteristic of this style of work. To complete this painting it would be necessary to work into the smaller forms and redefine several elements which are a little too basic in this demonstration.

Surface qualities

The surface of any painting owes its character to a combination of three main factors; ground/base, brushwork and the consistency and quality of paint.

The relationship between these factors can be understood most easily by practising painting on to various textured grounds with different brush types and sizes and with varying consistencies of paint. If you were to keep a systematic record of each of these exercises you could see in advance something of the surface quality attainable with your own equipment and materials.

Although some of the previous sections and visual examples in this book have referred to this subject I shall emphasise the main methods of controlling surface qualities in greater detail.

First, consistency must be the key to the use of these techniques. Do not employ a wide range of them in one painting.

Since the ground quality and texture really do affect the final appearance of the painting, try to make use of this fact as much as possible.

There are several techniques which emphasise the ground texture; painting and then scraping with a palette knife is one. This leaves sufficient paint in the cavities of the ground texture to hold the image and it can be worked into later. If this later work is kept to a minimum a very pleasing surface effect is achieved in which the original ground texture plays a large part.

Another technique which can emphasise the ground texture is glazing. Glazes are mixtures of linseed oil, a little picture varnish and very little turpentine stained with whatever colour you require. Applied over the ground base they can be scrubbed in loosely for a vigorous-looking brushed effect or painted on smoothly for deep shadowy areas. To emphasise the ground texture even more, glazes can be wiped lightly with a soft cloth pad which again leaves the paint in the hollows of the texture and clears the surface of most of the colour. Naturally the stronger the texture beneath the glaze, the greater the effect of this method.

Glazes add a quality of depth to the painting surface but must be handled carefully as they can, if used indiscriminately, give a hard glassy effect.

Demonstration

Light plays an important part in paintings and an understanding of its qualities can help to produce works which contain an inner glow and extra dimension. In the demonstration which follows on pages 26–7, I have chosen a still life as a useful way of showing how light can be represented and held within the painting.

In this instance the technique employed is a simple combination of two methods of applying paint. This is to use solid pigment in the light areas; and in some cases to build up the underneath ground texture with white, which is allowed to dry, progressing through to the darkest shadow sections, gradually reducing the solid colour until these dark areas are painted entirely by the use of glazes. Thus the light areas appear to advance out of the darker shadowy section which, by contrast, appear to recede.

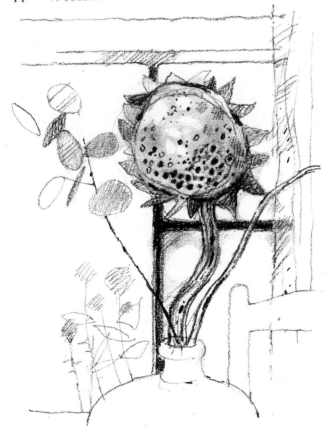

A sketch for the flower and jar (Detail 2, overleaf).

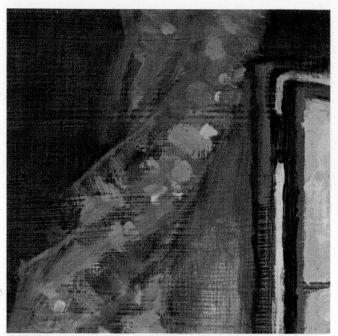

Detail 1

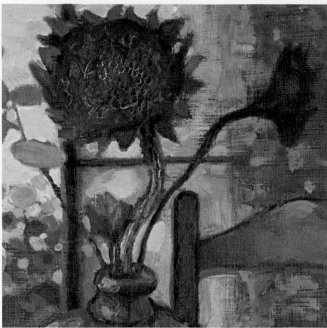

Detail 2

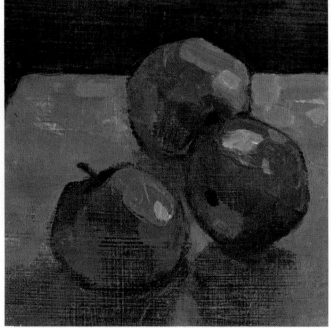

Detail 3

Detail 4

Detail 1

I apply two glazes, both of cadmium red deep and a little raw umber. I wait for the first to dry and then wipe out the area of illuminated wall with a rag and paint the curtain loosely with thicker colour into the wet top layer of glaze. This is a part of the painting where there are good examples of all paint surfaces – solid light sections, intermediate passages where we find the brightest and richest colour, and dark areas of glaze.

Detail 2

The dried sunflower is underpainted in white and, when dry, glazed with transparent golden ochre and cadmium orange with a little raw umber rubbed into the central texture (which is formed by indenting the original white in parts when wet with the handle of a small paint brush). The same technique is used for the stalk.

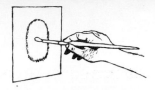

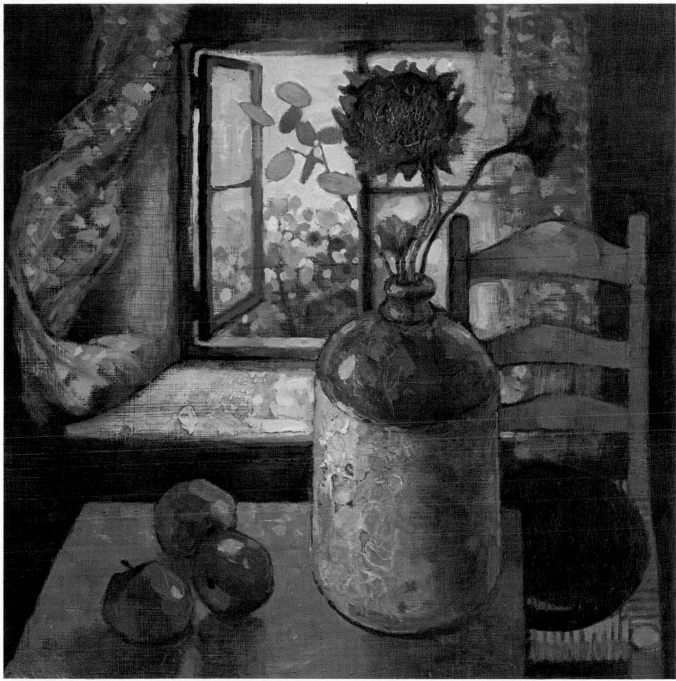

The finished painting

Detail 3

The painting of these apples shows how solidity can be obtained by using a good thick paint on the well-lit faces of the fruit, leaving the partially glazed areas to look after themselves, and then just tipping in a small dab or two of reflected warm light in the shadow side to complete the illusion of rotundity. This is also helped by the transparent cast shadow of the apples thrown on to the table. This is the original colour of the table top. Lighter, more solid colour is applied towards the window to give it substance.

Detail 4

Various textures using underpainting, fading round through shadow on the jar into reflected light, help the illusion of solidity. Also in this section is the darkest area of the painting, the cat curled up on the chair. This is produced by two glazes, first of raw umber and then one of permanent blue with a touch of black.

Mood and Atmosphere

Although these are usually suggested through using such elements as colour, form and light, sympathetic brushwork is essential. Scale is most important as the brush strokes could obtrude if they are too large, or appear fussy and laboured if too small.

A key to scale is often given by the subject itself. For instance, you are proposing to paint a group of trees in which the pattern of fine branches and leaves is what interests you. Rather than paint in each branch you might try instead painting the spaces of sky between the branches having first drawn them in rather more heavily than you might normally. The shape of the branches left by this method becomes far more varied and interesting and the problem of the scale of your brush strokes is solved as all your brushwork over the rest of the painting can be to the same scale.

For the above scale of working and for a painting of about 60 cm × 40 cm (24 in × 16 in) it would be well to use hog-hair brushes of around sizes 5 to 7, flat or round according to the elements in the work. For a very strong coarse effect one could use size 8.

Naturally for blocking-in early in a painting, a larger brush is most useful but, as the work progresses, use smaller brushes. For a very fine finish to a painting in which mood and atmosphere play a strong part, be careful not to use too small a brush. For the sizes quoted above size 3 is the smallest that can be usefully employed.

In some landscapes the mood is first set by the use of evocative colour – say, cool blues and greys if distance is to be a major element in the painting or yellow and brown if the subject is an interior lit by artificial light.

After the colour mood has been chosen, decide on the type of brushwork you wish to employ. Brush size and the form of the strokes need to be pre-determined so that the blocking-in of the large forms or areas can be carried out in the same character as the later work.

As the work progresses and the brush strokes become smaller in scale make sure that they keep the same character to retain the necessary unity throughout the painting.

The character of brushwork, its grain or direction of stroke, scale and form have an important influence on the painting so that the colour scheme and the methods of applying it combine to produce the appropriate mood and atmosphere.

Demonstration

I have prepared two paintings so that the mood and atmospheric qualities of the one on page 29 are contrasted with the flat two-dimensional character of the other on page 30. In this way I hope to show that brushwork in relation to subject-matter has a strong influence on the mood and that it can suggest things without actually defining them.

In the painting of the chapel on page 29 I decided that the predominant colour should be blue to help create a mood of cool freshness which I associate with this subject. I also wished to give the painting a suggestion of rain without actually painting falling water drops in any way. This meant choosing a form of brushwork which, by its scale, direction and the way it was applied would give this quality.

I chose to employ fairly large brush strokes in relation to the size of the painting and to give these strokes a sloping grain over the whole surface of the work irrespective of the forms I was depicting. The method of applying the paint was to lay it on loosely with flat hog-hair brushes; in some places using the thin edge of the brush with a zig-zag writing-like movement over a simple drawn outline.

I started by brushing over the whole surface a strong, slightly transparent blue as a base using a similar directional stroke when applying the colour.

I left a considerable amount of this ground colour showing between the strokes, and also allowed the original drawing to show here and there.

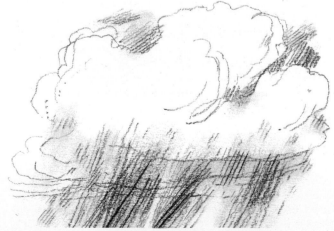

Clouds can set the mood for a landscape painting.

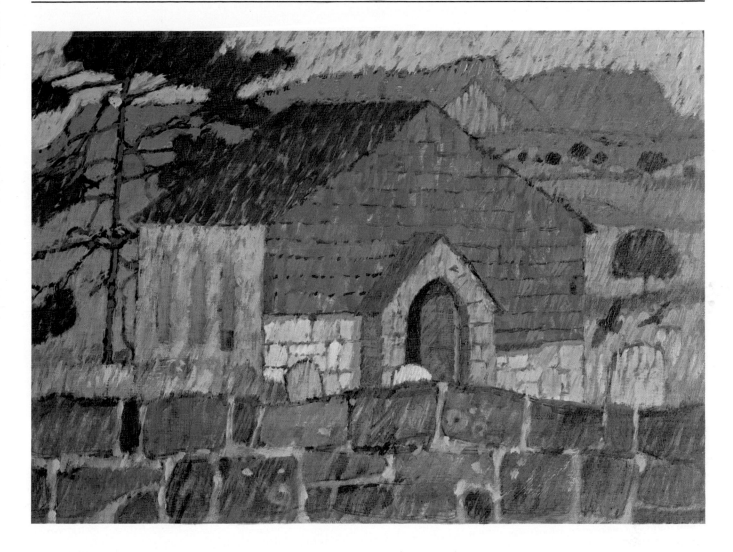

This painting is left unfinished in order to demonstrate the brushwork. Normally I would work into the distant areas, particularly in the sky and hills, to soften them and take them back. This would mean using a smaller brush, keeping the strokes similar and softening the outlines a little.

The painting on page 30, which is not atmospheric in any way, calls for a different treatment. Here the emphasis is entirely on the two-dimensional pattern of differing textures and surfaces. I varied my brushwork considerably to demonstrate the changes of texture needed to portray the differing materials. Having brushed in lightly the main areas over the drawn shapes using raw umber slightly thinned, I decided to leave this texture on the section below the window as it suggested the rough sawn quality of creosoted boards.

In some areas I left the colour fairly thin so that the texture of the ground could show through, but to bring out the flat quality of the large pieces of panelling I applied shortish straight brush strokes, slightly varying the colour and tone and leaving space between to allow the other texture of the underpainting to show through. This represented the surface of old plywood on which

Welsh chapel

The blue ground over which I painted gave me the basis to create the atmosphere of a cool rainy day. Even when I was painting in the warmer colours the ground shows through, and adds to the rainy effect I wished to achieve. This again is emphasised by the open, short diagonally hatched brush strokes I employed throughout the subject.

29

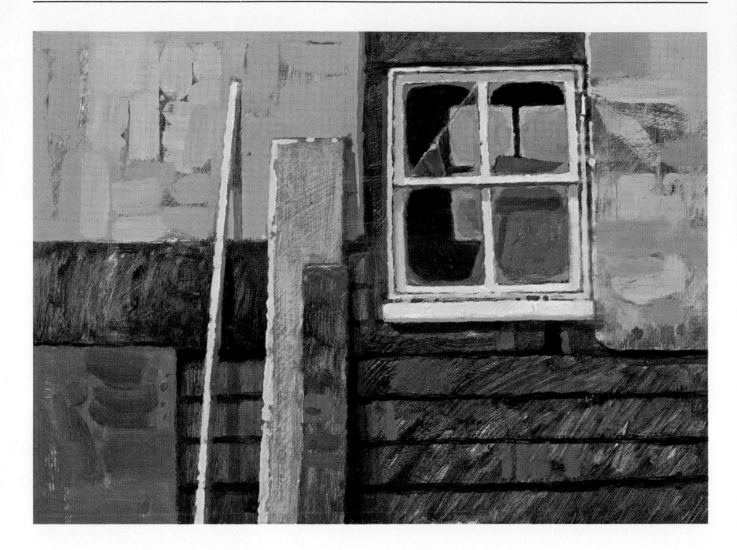

cement had been mixed. On the right of the window I have dragged the colour drily over the surface to help this illusion.

A little cast shadow here and there suggests the light and relieves the flatness just sufficiently to show the form of the materials, and the window gives a little more depth and a point of interest for the eye.

Although there are several different forms of brush-work within the one painting it is held together and given unity by the simple strong shapes.

The broken window

Although just a demonstration and not a completed picture, this shows how, compositionally, quite simple rectangular and square forms, relieved with a few diagonals, plus the use of tone and colour, can make a satisfying exercise. Each shape has its own complementary brushwork describing the various textures in the subject.

Do's and Don'ts: a brief summary

Do's

Do choose your basic tools sensibly. Spend sufficient money in purchasing them and look after them carefully.

Do consider your ground as an important factor in determining the final effect of your painting.

Do hold your brushes so that you can maintain maximum control without your wrist and arm becoming rigid and stiff.

Do relate the character of your brushwork to the subject-matter.

Do mix your paint on the palette rather than on the painting.

Do apply your brush strokes to the surface positively and cleanly.

Do mix your paint to the right consistency for the brush strokes you are using. Practice and experience will dictate the amounts.

Do maintain a unity in your painting by keeping the character of your brushwork consistent.

Don'ts

Don't overtexture the ground. Relate the scale of the texture to the size of your painting.

Don't let the scale of your brushwork become more noticeable than the subject-matter of the painting.

Don't use several different systems of brushwork in one painting.

Don't allow the paint to build up too much on the painting. Scrape the surplus away with a palette knife if necessary and repaint.

Don't scrub the paint on to the surface with flat brushes when starting. These are made for a stroking or dabbing movement. Round section brushes are better for any large-scale basic blocking-in during the early stages of a painting.

Don't become over-ambitious. Steady practice can be most enjoyable and productive.

Don't practise, at least to begin with, on complete paintings. Use small pieces of board prepared with variously textured grounds and try out the techniques described here several times before applying them to actual paintings.

Don't let paint dry in brushes.

Don't dip your brushes into the original jars or bottles containing oil, varnish or turpentine. Pour out a little into old tins or, better still, use dippers, small containers which clip on to the palette.

Drawing

by Peter Gilman

In itself, drawing can be as satisfying as painting. However, most drawings serve as aids to painting, helping us to select and position subjects to their best advantage, establishing satisfying and even dramatic compositional lines and, by the use of shading and hatching, blocking in tonal values.

I advise everyone who wishes to paint, amateur or professional (the latter nearly always do!), to carry a small sketchbook at all times, together with pens and pencils. When you go out on a painting expedition have a pad of inexpensive paper on which to do your rough work, as well as a better-quality sketchbook of cartridge paper. A tonal sketch of a subject might lie dormant in a ringbound sketchbook for some time until the desire comes to render it in colour. I constantly look through my filed-away sketchbooks for inspiration; the drawings in them may even help me plan another excursion. No matter how brief a sketch might be, it is likely to be of some use long after it was committed to paper.

Draw as often as you can, for the practice of coordinating hand with eye will undoubtedly improve your painting technique. Control of brush on canvas is but an extension of control of pencil, pen or crayon. If I cannot paint every day at least I do a little sketching.

A subject need not be complicated to be good – an original simplicity in line and form is the keystone of all art, not lavish detail. 'See through' a subject, however outwardly complicated or detailed – a quick sketch of compositional and tonal fundamentals will soon tell you whether it is worth pursuing or dropping. Move about between sketches; what might appear to be an interesting viewpoint may be even better seen close-to or from a few metres to one side.

The sketches on these pages give you an idea of what my reference sketchbooks contain, and to which I am constantly adding. Artists in towns and cities can practise by drawing a pile of dishes in a sink, or sketch from a shop doorway a view across a street – take any and every opportunity to keep your hand in.

As for the camera, and drawing from photographs, I never use one, since I prefer to copy nature and real life, but some artists produce excellent work from photographic reference material. It is a matter of choice and, perhaps, time.

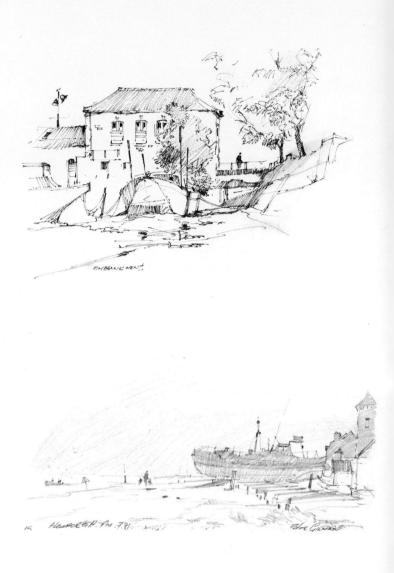

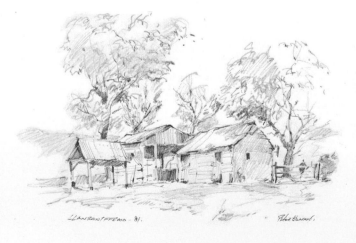

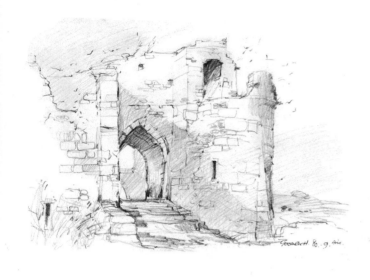

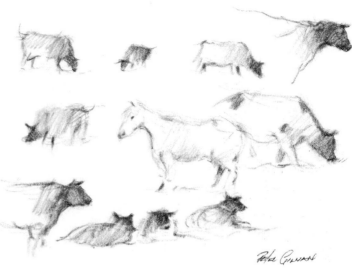

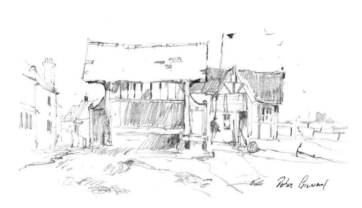

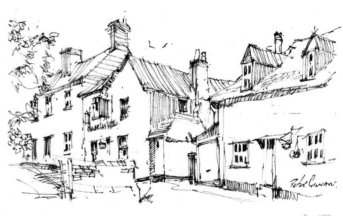

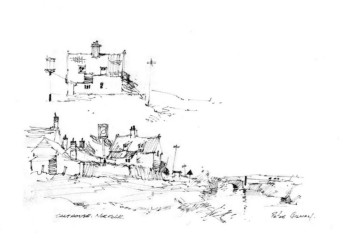

Painting outdoors

by Peter Gilman

For any figurative painter, advanced or otherwise, there is no more satisfying exercise than working *in situ* from nature, making direct statements from the subject, through eye and hand, on to canvas. Such first-hand experience teaches us the craft of pictorial selection, and offers the feel of the elements that make up a picture. When painting outdoors one is totally involved.

Besides painting outdoors, draw as often as you can; draw tonally, and your paintings will improve tonally. Outdoor subjects can also, without losing pictorial value, be painted with just a few essential colours and mixtures of them; most old and modern masters can and have produced brilliant paintings with surprisingly little materials and equipment.

By taking your equipment outdoors and painting directly you will discover the variety and subtlety of the weather and seasons, and the effect they have on landscape. The result may be a colour sketch which you might wish to work up into a more formal picture in your studio, or a completed picture: whatever you take home with you at the end of the day will have gained an immediacy and freshness from being 'at one' with your subject. With time and practice that feeling will be transmitted through your paintings to those who look at your work; the veracity that only a painting derived directly from nature can give.

Equipment

We have reviewed suitable brushes, easel, palettes, grounds and supports on pages 8, 9 and 10. When painting outdoors the following items merit special consideration.

Seating, stools etc.

I prefer to stand when painting, as that enables me to move back from my work. If you want a seat, use one which is stable. An umbrella is useful too – not only for keeping off showers, but for shielding direct sunlight from your canvas.

Clothing

How you dress to deal with the different seasons is very important for comfort. In warm weather we must keep cool. Wear a shady hat – never paint in sunglasses. Insect repellent is a useful item to carry in hot weather.

In winter keep your feet warm with wool socks and good boots. Thermal underwear is very helpful. A coat with a pure wool lining is a good investment (e.g. Parkas). A pair of gloves with thumb and forefinger removed from the brush hand is a must. Remember, always keep your feet and hands warm; you cannot concentrate if you are cold.

Pochade boxes

Pochade boxes are not often seen being used by painters outdoors nowadays – a pity, for they have many advantages over the more cumbersome equipment employed by some of my students. A pochade box offers most of the advantages a sketchbook has, except that your result, however rudimentary, is in colour, and in oils. It combines, in complete and handy form, all the basic equipment for oil sketching outdoors.

No easel is required; the lid, when opened, contains the sketch panels, the palette slides out to the side leaving the box contents readily available: a few basic colours in small tubes, a couple of cut-down brushes, screw-top dippers and a bottle of dilutant – even a small rag on which to wipe your brushes. A cunning but old-fashioned device (one can learn even from the landscape painters of the nineteenth century who used these ingenious boxes extensively outdoors) is, on the smallest boxes, a thumbhole hollowed out in the bottom of the box so that you can hold *all* your equipment *and* painting panel in one hand, leaving your painting hand free.

Larger pochade boxes can be rested on the knees while sitting; some of them have clips in the lid enabling one to place in it both upright and horizontal panels. A few firms still manufacture them, but if you are fortunate enough to see one secondhand, snap it up. Pochade boxes fit easily into a carrier bag or rest comfortably on the rear sill of most cars.

Village Street. Size: 30 × 22¹/₂ cm/12 × 9 in. Acrylic primed masonite. By almost dividing the picture's surface into two halves, I came near to breaking an elementary compositional rule. Eventually, placing myself and my easel so that I could see the road diagonal continue up through the picture with the roofline of the left-hand cottages, I noticed that the tree inclined from its base to the centre top in the same direction. With these two guidelines I was able to lead the eye through the village street to the distance in a more satisfying and dramatic way than would have been achieved by painting from the roadside.

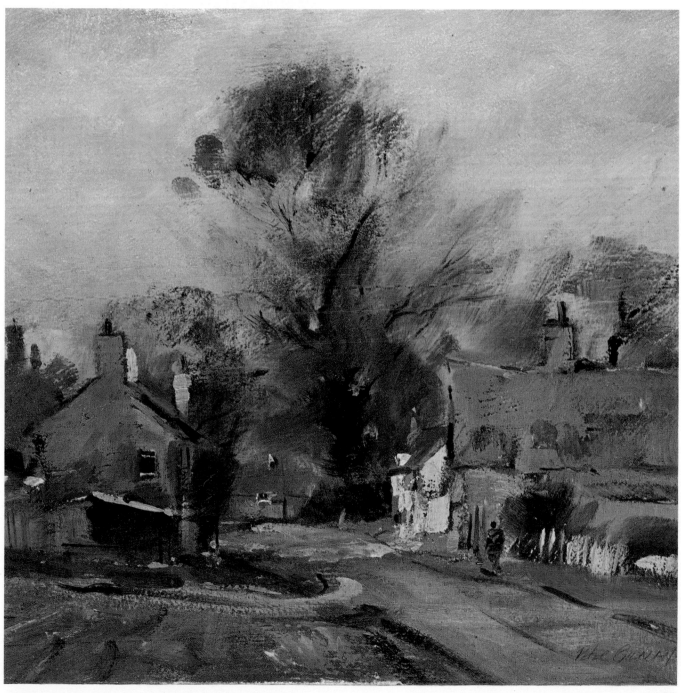

Landscape Painting
by Norman Battershill and Peter Gilman

Introduction

Landscape painting has been written about more than any other subject in art. A landscape offers an infinite variety of shape, colour, composition and complexity of form that has something to stimulate almost every painter. This chapter is an introduction to landscape painting in oils and concentrates on the techniques of composition and handling paint.

The finest landscape paintings are the result of careful observation, good drawing, clear interpretation and sound painting technique. Careful observation comes with studying the land and looking at its form, texture and colour. It is best to learn to do this by spending as much time as you can drawing outside in all weathers. If you are comfortable, you can study a scene for as long as you need to understand it and do a useful drawing that contains enough information to create a painting in the studio later. Draw as often as you can, as practice improves style, technique and accuracy more than anything else. Your own interpretation will make the difference between painting a landscape and merely producing a photographic likeness. Techniques of handling materials are the easiest aspects of painting to learn, but should not become an end in themselves. A really effective painting requires a great deal more than just technique.

It is always best to draw and paint outside whenever you can. Oil colour is particularly suited to painting the landscape as it is capable of a great variety of expression and can be reworked or painted over if desired. If you are a beginner, keep your materials and equipment to a minimum. Economical use of paint and careful use of colour are good rules to remember.

Drawing outside

Drawing outside is extremely enjoyable, increases your powers of observation and is the main source of ideas and reference for painting in the studio. With practice, drawings help to establish an idea and the composition of a subject. With experience, a few marks on the paper can make a strong statement. Look through the drawings in this book and you will see that it is not always necessary to use shading or thick, dark lines.

It is unnecessary to buy an expensive sketchbook, as a scribbling pad is just as likely to have an acceptable drawing surface. Try always to have with you a sketchbook and pencil: there are many times in the day when you can do a quick drawing and short, regular practice is the most valuable way of improving your skill.

The two easiest ways of working are either to begin drawing at the point of interest and work outwards, or lightly to block in the main shapes and add detail afterwards. The drawings opposite illustrate these two methods well.

Use a soft pencil and experiment with carbon pencil and charcoal to produce a variety of dense black lines and textures. Draw lightly and resist the temptation to erase mistakes. If your drawing goes drastically wrong, start again. Before you throw away a bad drawing, study it and analyse where it has gone wrong: you will learn a great deal from doing this.

Finally, make basic colour notes to use as a reminder when you come to paint the subject indoors.

Above right: Size: 279 × 190 mm/11 × 7½ in. Lithographic pencil on grey paper. The soft shading used on the bank gives a strong contrast to the untouched paper that represents the pond, and gives a feeling of strong light on water. Ripples and reeds add interest and movement that balance with the tall branches on the left.
Below right: Size: 178 × 140 mm/7 × 5½ in. Carbon pencil on white drawing paper. The subject provided a good exercise in balancing dark against light, and vice versa. The small tree on the extreme left helps to make the background recede.

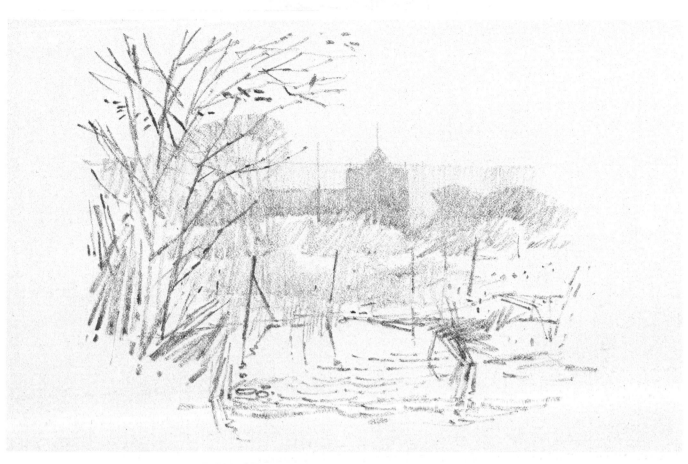

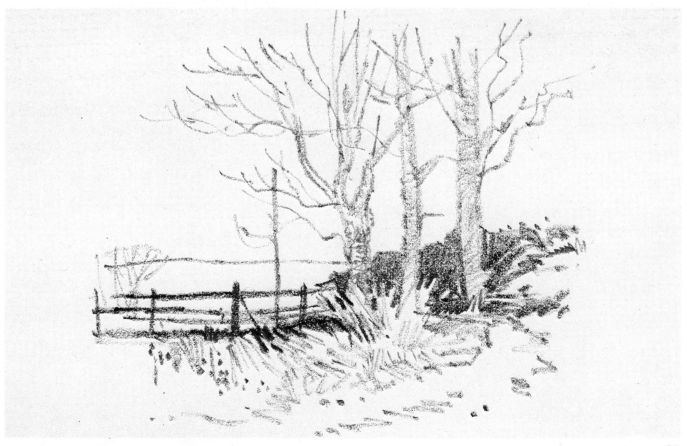

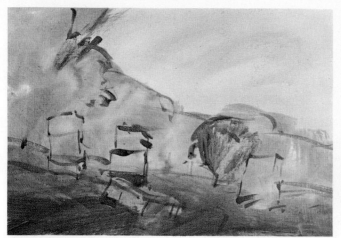

Stage 1

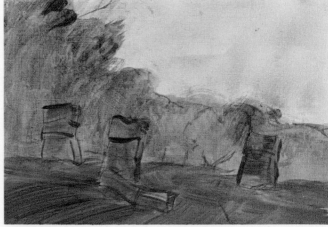

Stage 2

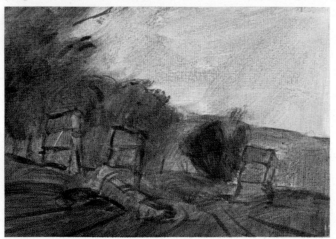

Stage 3

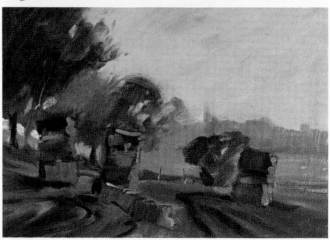

Stage 4

Cornbales: demonstration

by Peter Gilman

The evening light striking these stacked bales after harvesting provided a simple subject with interesting shapes in a rural setting.

Size: 30 × 22½ cm/12 × 9 in. Acrylic prepared masonite. Brushes: filbert Nos. 8, 5, 4, 2 and No. 4 sable. Colours: ultramarine, light red, yellow ochre, lemon yellow, burnt umber and titanium white.

Stage 1

I draw in the general shapes using a mixture of ultramarine and burnt umber with a No. 4 sable; and work a warm wash into the sky area using light red and yellow ochre with a No. 8 brush. I then work in the distant tree shapes with yellow ochre, and the corn stubble with burnt umber, working around the bales.

Stage 2

Warm blue grey and blue green is introduced into the tree shapes. I use orange for filling in the bales mixed from light red and lemon yellow. No white is used at this stage. Keep the drawing crisp, and restate as necessary.

Stage 3

Establish shadows and the direction of light; and darken the shadow areas on the cornbales using burnt umber and ultramarine. I draw in the right-hand tree with ultramarine and yellow ochre against the cornbales, remembering to contrast dark against light and vice versa. Keep the drawing relaxed. Re-assess the sky warmth.

Stage 4

I paint the sky around the tree shapes and distance with blue and white using broken brushwork; then suggest the receding fields using yellow ochre and pale greens in

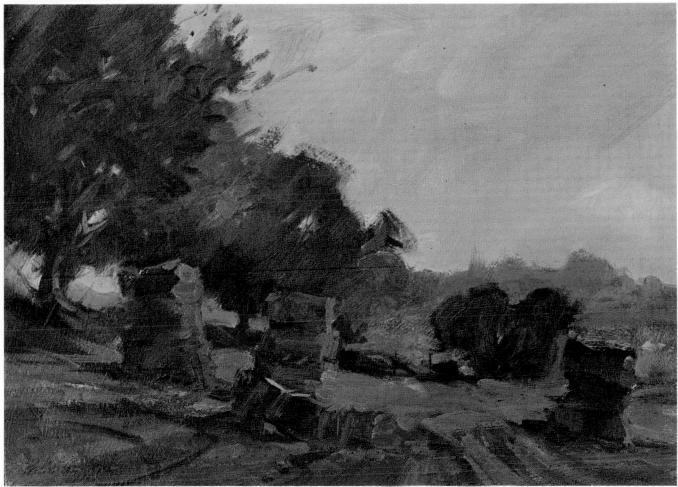

Stage 5 – finished painting

the foreground, grey-blue beyond. The foliage on the
left area is painted in with ultramarine and yellow ochre.
I break the sky into the tree shapes, keeping the edges
soft, and strengthen the colour of the bales, creating
contrasts with bright oranges and yellows on the right-
hand sides of the bales. Keep these shapes relaxed, as
they stand unevenly.

Stage 5 – the finished painting

I adjust the tonal values to achieve distinction of shapes,
and restate the middle distance in order to give the
correct recession of landscape. Finally I add details,
conveying the feeling of waning light.

Although the finished painting may appear slight, it is
complete enough to achieve spontaneity. It helped me to
practise my observation of transient light and my ability
to capture a subject in quickly changing conditions.

The elements of composition

Commentary and pictures by Peter Gilman

Selection is a vital part of the painting process. A viewer can serve well here. Cut one from a piece of stiff card, with an aperture of 3″ × 2″. Hold it to your eye or away from your eye to increase or decrease the area of interest. The small sketch opposite describes the subject I was interested in and from the wider seen subject I was able to bracket off my final selection to the finished drawing which eventually became a larger painting.

In landscape painting do not place the horizon line too near the centre of your panel. A general rule is two-thirds sky to one-third landscape, or one-third sky to two-thirds landscape, as seen looking down on a subject; but rules can always be broken so long as the subject-matter is of sufficient interest.

If at all possible, select a viewpoint with your back to the sun and wind. Having completed your sketches in pencil or crayon, make sure that the shape of the panel you are going to use conforms with the picture you want to paint. This is not as simple as it sounds; one often finds in a beginner's work an awkwardly placed horizon, or a feature drawn in too large or small merely because the scale and shape of a preliminary sketch has not been 'thought through' to the panel. When drawing in your composition with the brush, make sure at the outset that the outlines and tonal blockings 'sit' comfortably on the panel, so that you are confident *beforehand* that your finished result will be in keeping with your intentions. When painting small panels the exact placing of the drawing on it is vital – do not rush in and apply colour immediately but stand back and consider your subject and your panel to ensure the rightness of your work at the outset. Looking at your drawing and blocking-in through a small pocket mirror, which laterally inverts the image, will reveal any compositional faults.

Once started, work overall, balancing chromatically and tonally the large areas as the picture progesses, leaving detail until last. A 'high' spot of colour, such as a red door of a cottage or a white sail, should, however, be suggested fairly early on in order to gauge its effect on the tonal balance of your picture.

A cardboard viewer, as I have suggested, can be invaluable in helping to select the picture you want to paint. Using the viewer, make preliminary sketches of what you see through it. Experienced artists will choose to view a subject in a way that is not only compositionally satisfactory but may present an unfamiliar aspect of what might otherwise be a common-place scene. One of the pleasures of outdoor painting is to paint the familiar from a fresh viewpoint, so that when a person looks at your picture the subject may be instantly recognisable but has that increment which provokes the response, 'I've never seen it from there before'.

Most people look at much of the landscape through windows – whether in their own homes, or from cars, buses and trains. Get off the beaten track whenever possible. Not only will you pleasantly surprise yourself, but others too when they look at your finished results.

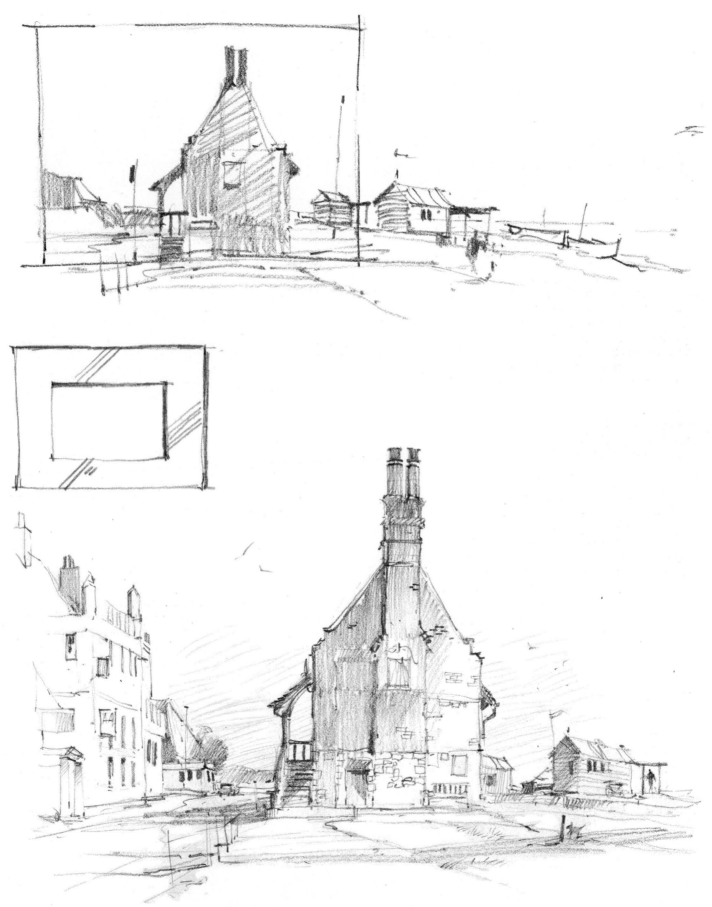

Stage 1

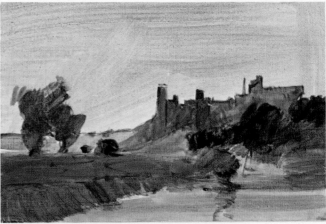

Stage 2

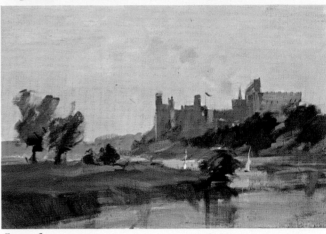

Stage 3

The Castle: demonstration

Arundel Castle in Sussex has a dramatic setting on a hill overlooking the plain through which the river Arun winds.

Size: 35 × 25 cm/14 × 10 in, canvas on board, medium grain. Brushes: filberts Nos. 8, 5, 4, 2 and No. 4 sable. Colours: ultramarine, light red, yellow ochre, burnt umber, lemon yellow, alizarin crimson and titanium white.

Stage 1

I begin with a diluted wash of ultramarine to the horizon and, for the land area, a covering of yellow ochre, stronger on the left, brushing it out to the right-hand side with a hint of ultramarine. With the No. 4 sable I draw in the general outlines. Then with the No. 5 filbert I suggest the general shapes with a diluted colour, using ultra and burnt umber. No white is to be added to the work at this stage.

Stage 2

Using ultramarine, burnt umber and yellow ochre, I suggest some of the darker areas, looking at the tonal pattern, then drawing in the castle with burnt umber. I then block in the dark tree shapes against the lighter sky and castle wall working from the distance to the foreground. A blue grey for the distance strengthens the drawing.

Stage 3

I work from the sky into the subject as a whole and use titanium white to achieve colour and tonal values. With a mixture of ultramarine and white paint in the sky, adding clouds using white with a touch of light red and ochre, brushing blue grey into the river area, working around the strong shapes. Darkening the mid-section,

the bush reflection, I smudge downwards with my little finger, darkening the river bank with a mixture of burnt umber and yellow ochre.

I next relate the meadow to the river bank with green and with the No. 4 sable suggest the two sails: placing them carefully I then begin to add general light and shade to the castle.

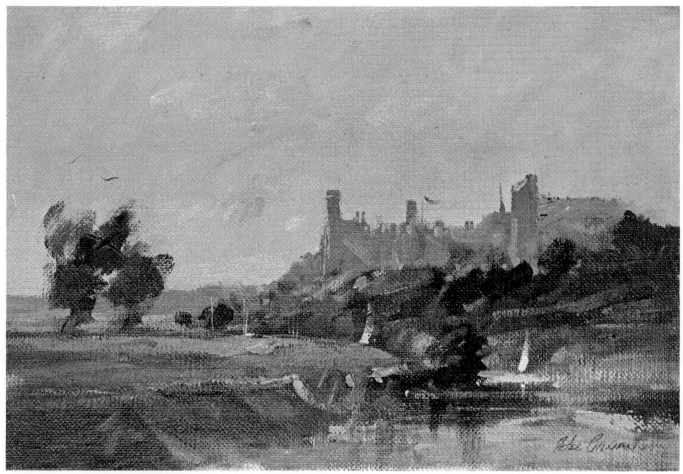

Stage 4 – the finished painting

Stage 4 – the finished painting

Considering next the shadow and light areas in the castle
towers and battlements I use ultramarine, light red and
only a hint of crimson to block in the castle more firmly. I
paint in the meadow using more green, and ultramarine,
yellow ochre, and touch of lemon yellow to give it light
and shade. I put in the strongest lights to bring the
subject into perspective; and notice the sun catching the
large battlement curve. Finally I crispen the sails, and
draw more pattern into the water, working horizontally
with the No. 4 sable to completion.

I feel I was successful in capturing a scene bathed in
the light of a summer morning when the highlights and
shadows dramatised the subject to particular effect.

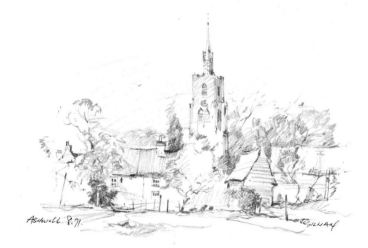

Stage 1

Stage 2

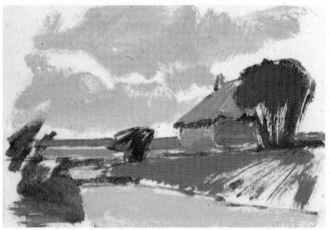

Stage 3

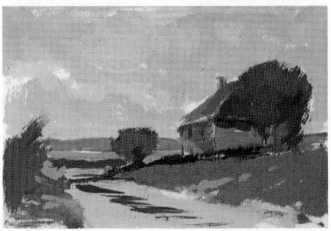

Stage 4

Red Brick cottage: demonstration

Size: 267 × 190 mm/10½ × 7½ in. Oil on primed water-colour paper. Brushes: 5, 9 bristle, sable rigger. Colours: cobalt blue, cadmium red, ultramarine, burnt sienna, raw sienna, lemon yellow, titanium white.

Stage 1

First mark out the outlines and main shapes in the painting with a mixture of cobalt blue and cadmium red thinned with turpentine. To prevent chalkiness, it is best not to use any white paint at this laying-in stage. If you wish, you can draw-in with charcoal, but I always use a brush because it is more direct.

Stage 2

After you have drawn in the basic composition, roughly indicate the dark areas to determine the main tonal contrasts.

Stage 3

Now block in the principal colours in bold masses. These are not the final colours; you can adjust colour and tone later to pull the painting together as it progresses.

Stage 4

You can leave the painting at this stage, as a simple statement, but it will improve if you work more colour into the painting, aiming for contrast between light and dark. When doing this, do not make the contrast too hard; try to achieve a gentle balance. The colour and tone of the subject is now complete.

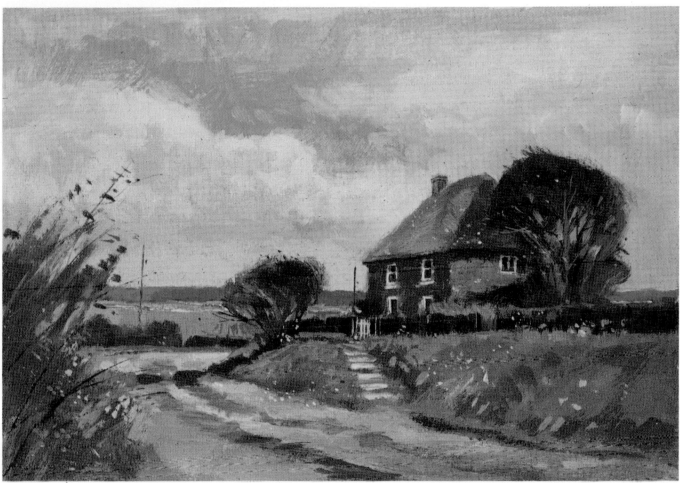

Stage 5 – the finished painting

Stage 5 – the finished painting

Soften off the edges by blending them with a clean brush, while the paint is still wet. Leave a firm line here and there to contrast with the soft edges. Add the steps up to the cottage on the wet paint, completing them in one go. Create more interest and depth by adding detail to the windows. Put in some poles to provide a strong contrast to the prominent horizontal lines in the painting. Add a few leaves and flowers and then leave the painting alone.

It is tempting to go on adding detail, but if you do, the picture may become too tight.

Stage 1

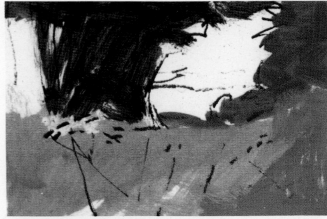

Stage 2

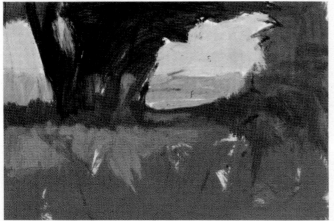

Stage 3

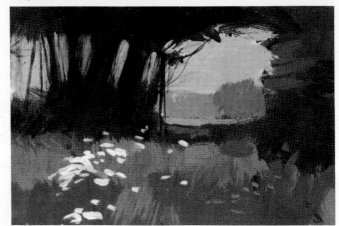

Stage 4

Sunlight and shade: demonstration

by Norman Battershill

Size: 267 × 190 mm/10½ × 7½ in. Oil on primed water-colour paper. Brushes: 5, 9 bristle, sable rigger. Colours: ultramarine, burnt umber, cadmium red, yellow ochre, cadmium yellow, titanium white.

Stage 1

This is a far more complex subject than it appears at first. To simplify it, draw the outlines of the basic shapes.

Stage 2

Put in the dark shadows of the main clump of trees, then with a mixture of yellow ochre, ultramarine and white, indicate the grass and the shrub on the right. Keep the paint thin when you do this so that it has texture and translucence.

Stage 3

Now establish the middle and far distance, so that there is a strong effect of recession at this early stage of the work. Mix yellow ochre and ultramarine with a touch of cadmium yellow in different proportions and block in the shadows on the grass and bushes on the right.

Stage 4

Suddenly, this painting is nearing completion, but still resist the temptation to start adding minor details. Concentrate on the middle distance and put in the far tree and strip of cornfield to give greater effect to the tunnel under the branches. The splashes of white and tinted lemon yellow in the foreground grass give depth and substance to an area that looked barren in Stage 3. Do not try to paint the flowers in the foreground, but merely indicate their presence in a broad painting like this with small splashes of colour. Work more stems and creepers into the dark tree on the left to give thickness to the undergrowth.

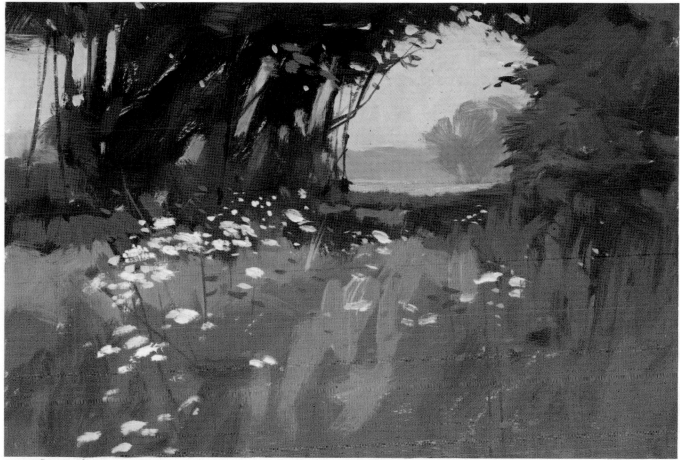

Stage 5 – the finished painting

Stage 5 – the finished painting

There are only a few minor alterations to be made now. Add some thick, crisp brushwork to the trees and bushes to give body, and paint another cornfield in the middle distance. Bring out the stalks of the flowers carefully so that they echo the shape of the branches of the dark trees. Add another tone of green to the bush on the right to develop more shape. Lastly, compare this stage with Stages 2, 3 and 4 individually to see how small, subtle changes define more clearly the pattern of basic tonal values set in Stage 2.

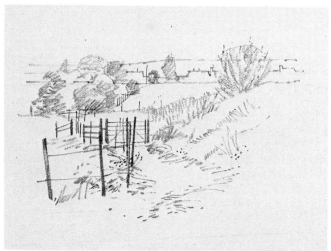

Generally a foreground should not be too obtrusive, otherwise interest remains at the bottom of a painting or drawing.

47

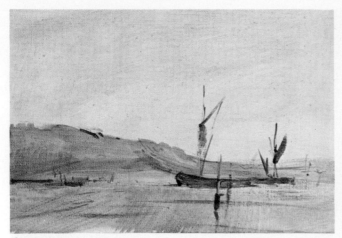

Stage 1

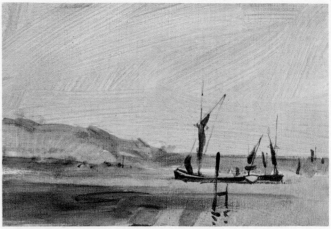

Stage 2

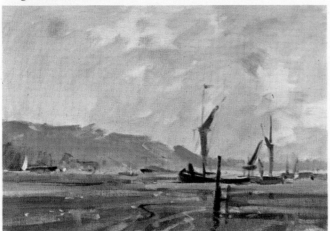

Stage 3

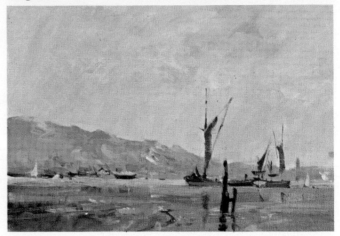

Stage 4

Barges on the river: demonstration

by Peter Gilman

The river Medway was one of the last rivers in England to be worked by sail, the ubiquitous Thames barge being its workhorse. Now these picturesque barges are no longer working; but many can be seen around the East Coast as pleasure craft.

Size: 25 × 17½ cm/10 × 7 in. Canvas covered board. Brushes: filberts Nos. 8, 5, 4, 2 and No. 4 sable. Colours: ultramarine, cobalt, light red, yellow ochre, lemon yellow, burnt umber and titanium white.

Stage 1

I work a warm grey sky wash over the top two-thirds of the painting area, using ultramarine with a little light red. Then I wash the bottom third with cobalt and a hint of ochre to produce a grey green, darkening the hill shapes with a small quantity of ultramarine. When this dries off, I draw in the main shapes with warm grey with the No. 4 sable.

Stage 2

Introducing more broad areas of colour working from distance to foreground, I place warm lights into the distant hills, suggesting buildings with light red and yellow ochre. I darken the foreground water using ultramarine and a hint of yellow ochre, keeping my brushwork horizontal at this point. The drawing of the barges and the mooring posts must be kept crisp.

Stage 3

I paint warm orange into the distant lower sky using light red and lemon yellow and a small quantity of white, keeping the paint as dry as possible. I darken the distant hills to warm blue grey using ultramarine and light red with white. Then I brush in the upper sky broadly – mostly ultramarine with a touch of light red lightened with white. I put more detail into the barges, darken the

Barges demonstration

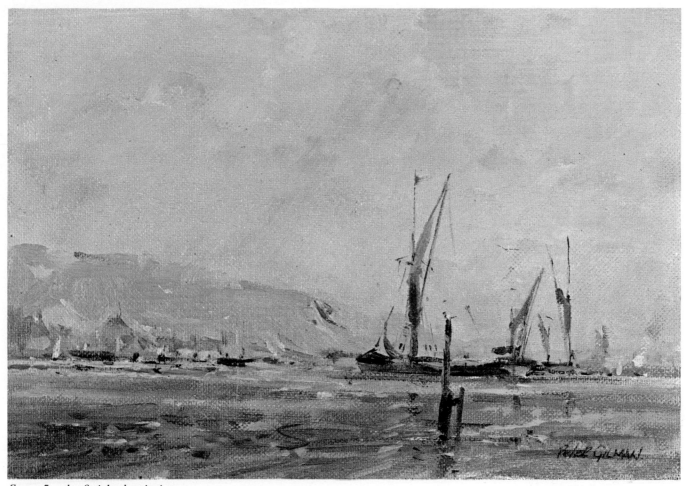

Stage 5 – the finished painting

hulls with ultramarine and burnt umber, and paint the sails light red with a hint of ultramarine, and the rigging dark grey. I lighten the chalk quarry with ochre and white, suggesting the sails of other boats and the lights in the foreground water with cobalt and ochre.

Stage 4

I work more warm lights into the sky, using orange and ochre, then place with care the reflections in the water. Always try and keep the surface of water as simple as possible, taking care not to over-paint it. Detailed lights are introduced into the distant buildings and boats. I then sharpen the contours on the hills. The tarpaulin on the barge and the green transom (aft end) I add to balance the picture, taking care not to over-detail distance, for the picture must recede.

Stage 5 – the finished painting

When softening the hills in the distance I am careful not to lose the sloping contours. I add rigging and highlights to the barge and adjust any tones that appear too soft or harsh but without losing the spontaneous outdoor effect.

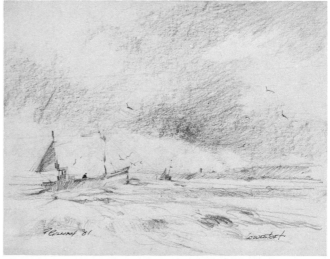

Drawing of fishing boats returning with a catch to Lowestoft.

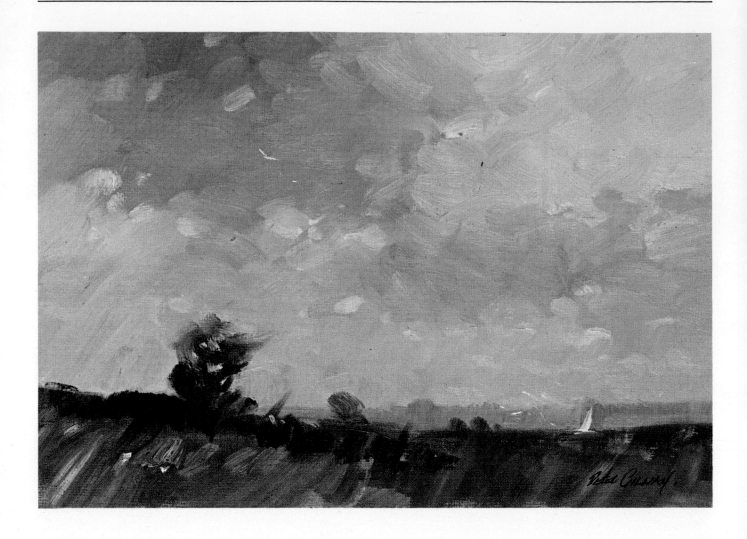

Skies and Atmosphere

by Peter Gilman

This is a vast subject: for there is no definitive way in which we can describe something which is undergoing such constant change. So often an outdoor painting is weakened by not enough consideration having been given to the composition and value of the sky.

It is quite usual for me to spend as long working on the sky as the rest of a painting. I suggest that you sit or stand considering the sky and light for some time before you pick up your brushes. There may be moments when the sky suits our subject best, and then we may have to paint from memory. Remember, a sky must recede as we create recession in the landscape.

Take a section of sky seen through your viewer, sketch it quickly in pastel, charcoal or watercolour to capture what you want to put down. Some oil artists use watercolour studies of skies to refer to. The sky affects all we see; clouds usually have light upper regions and shadowed undersides. All cloud forms should be soft and with gradation. A good practice is to select small panels and paint a sky on each from the same area at various times during the day, with only a suggestion of landscape, as in this small panel painted on a lively September afternoon. Use a finger to soften edges and blend and respond in unison with the brush; but remember to keep a clean rag with you and wipe the finger before each touch to keep the colours clean.

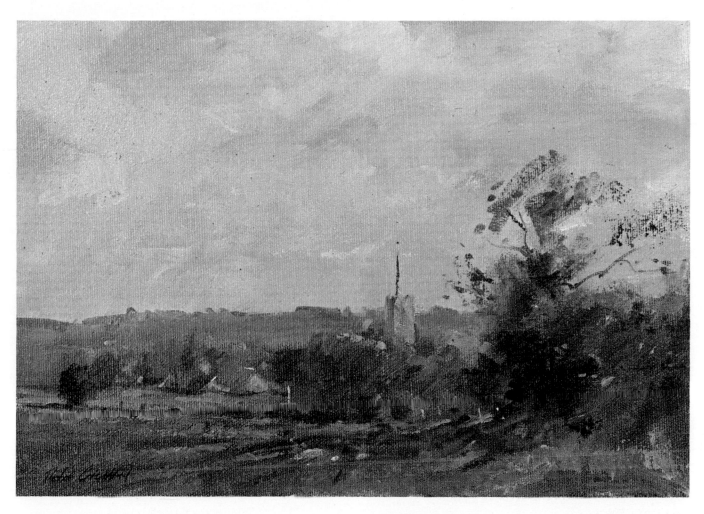

Middleton Church

Size: 30 × 22½ cm/12 × 9 in. Acrylic prepared canvas-covered panel. Brushes: filbert Nos. 8, 5, 4, 2 and No. 4 sable. Colours: ultramarine, yellow ochre, light red, alizarin crimson, lemon yellow, veridian, burnt umber and titanium white.

Not only does the weather affect what we see when painting outdoors, but also the time of day. The sun at morning and evening casts its slanting light through clouds across the landscape, throwing trees, buildings, hedgerows, posts and other substantial objects into relief, describing their forms more accurately and pictorially for the painter. At midday, or at an hour either side, it may reveal some stronger colours but less tonally. I prefer morning and afternoons, when shadows give added tonal value to the subject I want to paint.

Also, high summer can often prove more disappointing for painting than spring or autumn – the sun shining in a brilliant blue sky devoid of cloud may be pleasant for sunbathing but can be pictorially unsatisfying. Cloudy days with sun shining through them give both sky and the shadowed landscape so much more interest.

The cut stubble in the left-hand foreground is given contrast by the shadow thrown by the hedge and tree. The cottage gable ends and the church tower give light and scale to the subject. A lovely sky on this particular day also gave the subject extra life and movement. But remember, blue is a recessional colour, brown and reds tend to come forward. Observe the warm grey-blues in the distant sky pushing forward the warm light cloud forms above them.

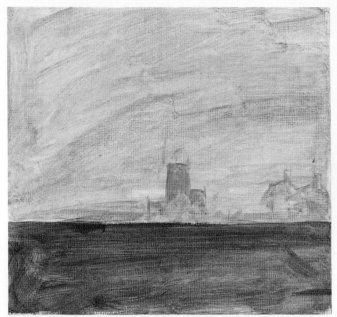

Stage 1

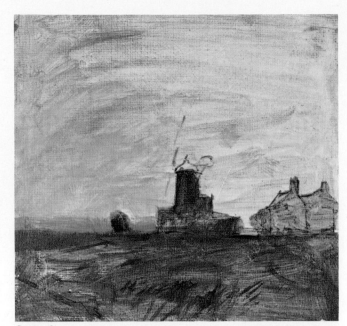

Stage 2

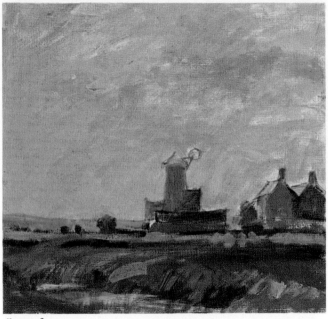

Stage 3

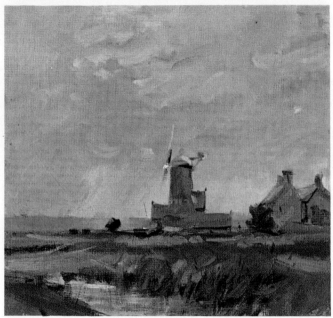

Stage 4

The Windmill: demonstration

Size: 45 × 45 cm/18 × 18 in. Acrylic primed canvas panel. Brushes: filberts Nos. 8, 5, 4, 2, No. 4 sable. Colours: ultramarine, light red, yellow ochre, burnt umber, lemon yellow and titanium white.

Stage 1

I chose a square panel for this subject in order to accommodate the strong verticals of the mill to balance sky and landscape. At a point, one-third up from the base of the panel, I strike a soft line; below this I put a wash of yellow ochre and a touch of light red mixed together. The sky area I brush in a blue slightly warmed with light red, and place the mill shape and horizon in a blue grey tone.

Stage 2

I begin by mixing ultramarine with burnt umber to produce a warm dark tone, and draw in the general shape of the mill itself, the adjacent cottages, foreground and vertical reeds, to bind the subject together. Then I brush a warm grey into the lower left area of the sky.

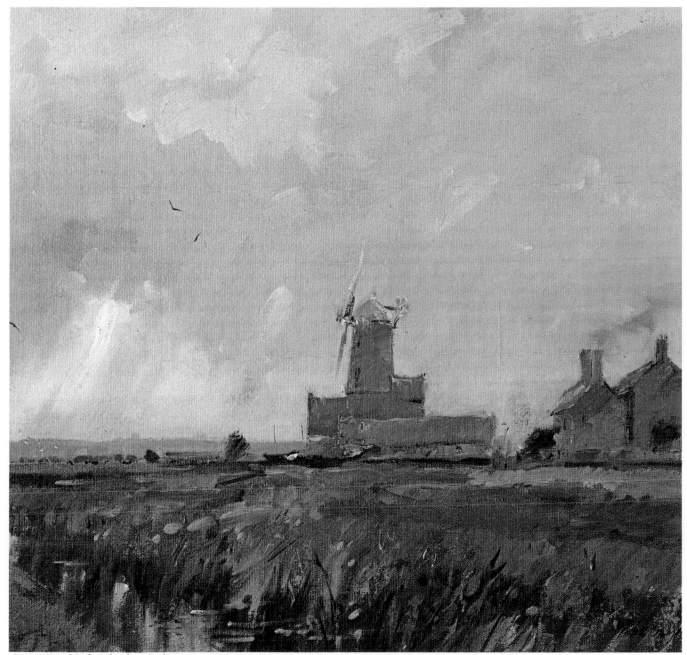

Stage 5 – the finished painting

Stage 3

Working the distant sky, I use a warm grey graduating from left to right, dark to light, forming cloud shapes, keeping all edges soft. The sunlit clouds are formed with white, yellow ochre and only a touch of light red, with the brushwork kept free and loose and using the No. 8 filbert. I darken the distance using white, blue and a touch of burnt umber, keeping the line soft. I then darken also the mill, and work the darks into the cottages. The reed beds I paint in a warm orange graduating to brown. The dyke (left foreground) is now suggested, a soft treatment of grey-blue using mid-tones to accommodate the lights and darks of sky and reed reflections. I also place the marsh tree clumps.

Stage 4

The mill and sails are finished using the No. 4 sable. I work in light orange reds and barn roofs, yellow ochre and white light breaking on the barn wall. Work from the distance to the foreground reed beds, and notice how the cloud shadow breaks up this area. I suggest reed details in darks and lights, also painting reflections in the water from the sunny patch of cloud.

Stage 5 – the finished painting

From the finished outdoor painting, which gave me the tonal and chromal values of the subject, and from pencil sketches, I decide to produce a more finished, larger painting of the subject in my studio.

53

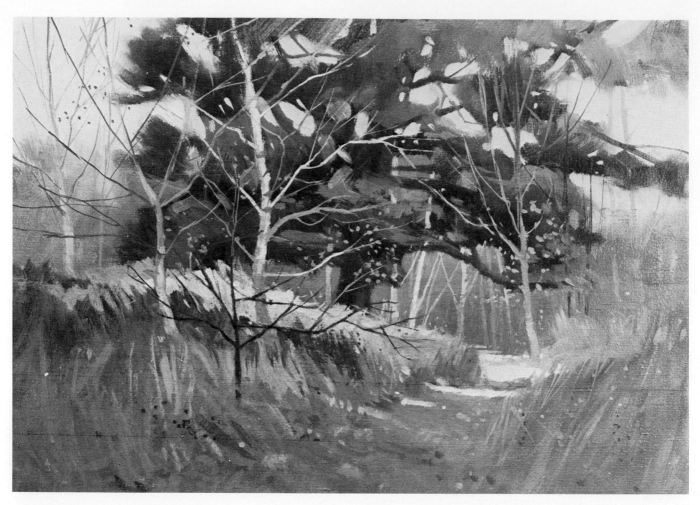

Studio painting

by Norman Battershill

Whether you have your own studio, or just use the kitchen table, landscape painting indoors is very satisfying and convenient, and the majority of artists work in this way. You can work on a more ambitious scale as there is far more time to consider mood, theme, composition and colour, and you can leave a painting for weeks and then return to it.

Of course, you need a great deal of reference material to work from and so you must do some work outside. The major disadvantage of working in a studio is that a painting can lose its freshness and the idea become stale and overworked. When you work outside and have only a short time to complete a work, it is necessary to make quick decisions and assessments. This may not always be to your liking, but the discipline will probably help you develop as a painter.

Reproducing a small painting on a larger scale in the studio does not have the same compactness or intimacy. Brush strokes, colour and tone are on a larger scale and have a different effect. It is better to use the original small painting as a starting point for something more ambitious with the same theme.

Above: Size: 610 × 508 mm/24 × 20 in. Oil on canvas. I painted this on a cold autumn morning. The main colours used are brown and yellow and the dark evergreen tree provides a strong contrast. When painting trees, try not to include too many different varieties in one picture. Here, the whippy young silver birches contrast with the large, lone pine tree.

54

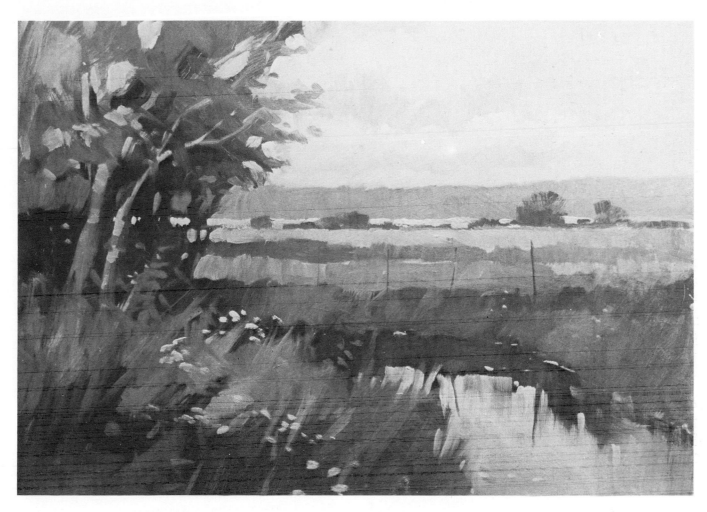

Size 610 × 508 mm/24 × 20 in. Oil on primed hardboard (masonite). This is an imaginary subject and typical of the countryside near my studio. A stretch of water in a landscape always adds interest. The reflection of the grass bank on the right is lighter than the bank itself. A simple rule to remember is that a light object always has a darker reflection and vice versa. Note how the visual interest is carried across the painting from the busy area on the left by the angle of the trees and grass in the foreground, creating a satisfactory compositional balance.

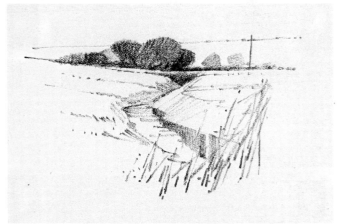

It is a good idea to make some small sketches first, to work out a composition in detail before painting commences.

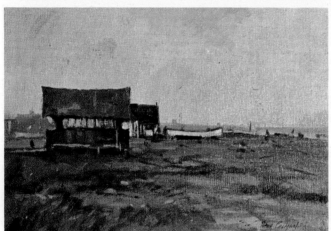

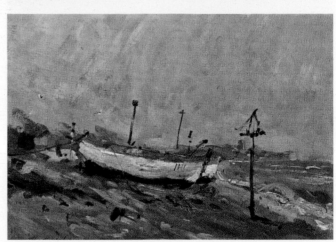

Finding your subject

by Peter Gilman

One does not have to travel vast distances in order to find variety in subject-matter. The four paintings reproduced on this page were all painted (at different times and weathers) within a hundred metres of each other near Aldeburgh beach. Do not decide straight away on arriving at a place that you have necessarily found the best vantage point; sometimes, by moving five or six yards, I have discovered yet a better viewpoint; at other times by turning around through 360 degrees, I have found at least two other subjects worthy of attention as on this beach! Travel slowly; on foot is far the best, for not only will you see more, but you can stop and consider, or move on, without any worry. No place is ever the same – I come back to some spots time after time, knowing that sun and cloud, morning and evening, all change the features of a favourite view. Develop above all the 'seeing eye'. The pictures above were finished on the spot without any further work being done in the studio.

Winter *(opposite)*

Size: 25 × 17½ cm/10 × 7 in. Acrylic-primed masonite.

Grey skies, bare trees, the snow on roads, fields, hills and rooftops can offer an artist a challenge as exhilarating as the flash of sunlight over a cornfield in high summer. But take heed of the advice given earlier about clothing – and be prepared to work quickly once you are out of doors.

If it is possible, make preliminary sketches of the subject you want to paint the day or the morning before, so that you know exactly the composition you wish to depict. Once outdoors work fast with a minimum of detail, trying to capture the overall elemental feeling. Back at home you can add minor items, such as the figure to give scale, a wind-blown bird, the telegraph poles, for you will have already recorded them in the preliminary sketches or have carried away such details mentally. Paintings like these can be bravura works in themselves, or used (with your sketches) to make a more considered work in the studio.

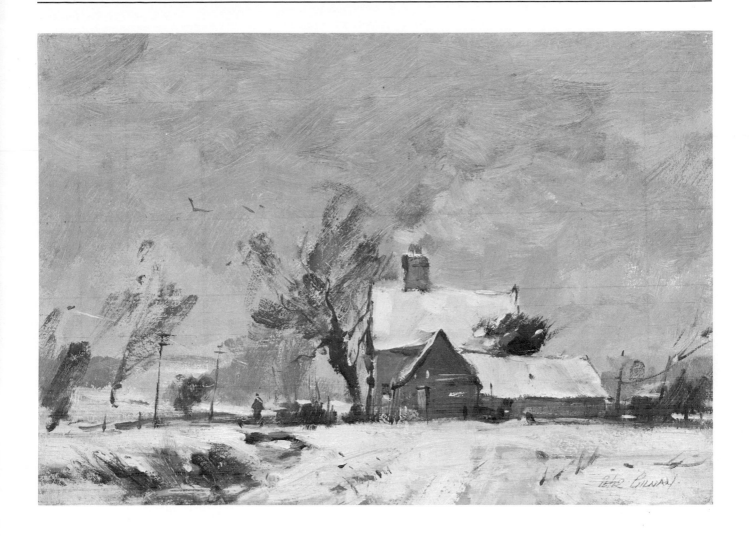

Do's and Don'ts

We have attempted to describe some of the joys and pitfalls in outdoor painting, but it may be useful to repeat some of them here.

Do practise your drawing, for it will make you a better painter, and give your hand and eye that ease of coordination which allows you to express yourself without thinking about fundamentals. Draw simply and quite small in your preliminary sketches, selecting carefully the one that satisfies you most before expanding it on to your painting surface.

When outdoors, make yourself as comfortable as possible: wear appropriate clothing, try to place wind and sun at your back. Don't be over-ambitious; concentrate on getting down the major statements of a subject simply and correctly, then you will build up your confidence to tackle more complex subjects. Don't overwork your picture; stop at the point at which you had set your mind when initially viewing the subject. Don't paint when you are tired; you will lose concentration.

Take kindly to good advice and criticism – you will soon learn to sort out what is worth listening to and what is not; but don't encourage interested onlookers – they will break your concentration! Keep your equipment light and practical, and look after it carefully, cleaning brushes and palette after each use.

Painting Portraits
by Dennis Frost

Introduction

Portrait painting is one of the most exacting subjects to tackle. Not only is the artist faced with the task of satisfying his own artistic judgement, but also the critical eye of the sitter, not to mention his close associates. Yet few subjects can give both painter and sitter such pleasure when the outcome is successful.

A landscape painter frequently has some latitude, and may, for the sake of good composition, 'move' a tree or a building to what he considers a more suitable site on the canvas.

A portrait painter has little such recourse except in posing the sitter, while even the removal of some disfigurement, in order to enhance the picture, may not be acceptable.

However, the painter is able to study the subject more sympathetically and subjectively than the camera and, with careful observation of features and mannerisms, he can produce a picture that is not only a good likeness, but gives insight into the character of the sitter.

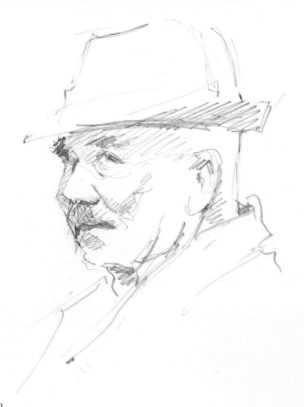

Preparation and Approach

Posing for a portrait can be tedious. Although the model should be prepared to sit for a stated time, frequent rest periods must be given. An interesting radio programme, or favourite taped music, will often relax and entertain your sitter. When the model is a child, a visual stimulus, such as a bowl of goldfish, or a caged bird will often hold their attention, leaving the artist free to concentrate on painting the picture.

When the preliminary negotiations regarding the number of sittings, the costume and the setting are completed, the first sitting can be started. During a sitting I like the conversation between us to flow for short periods; this way the sitter presents a variety of expressions without being aware of doing so, and one can observe how the shapes in the face alter, say, during animation and amusement, and so suggest not only the most appropriate physical picture to capture, but also the mood that motivates it.

Personally, I have an aversion to painting a broadly smiling or laughing portrait. It is all but impossible for the sitter to retain that sort of expression for the duration of a sitting and the strain involved becomes transmitted to me as the painter and the picture will suffer.

A smile completely alters the shape of a face. The eyes narrow, the cheeks widen and the distance between the top lip and nose shortens; humour, therefore, is not only conveyed by the shape of the mouth but also through muscular changes in the face and sometimes in the whole posture.

The preliminary sketch for the portrait is very important. If the shapes have been drawn accurately one can move on to colour and tone with confidence, but the drawing *must* be correct. To make sure, look at your picture through a hand mirror, for the reverse image will help to pinpoint any obvious faults.

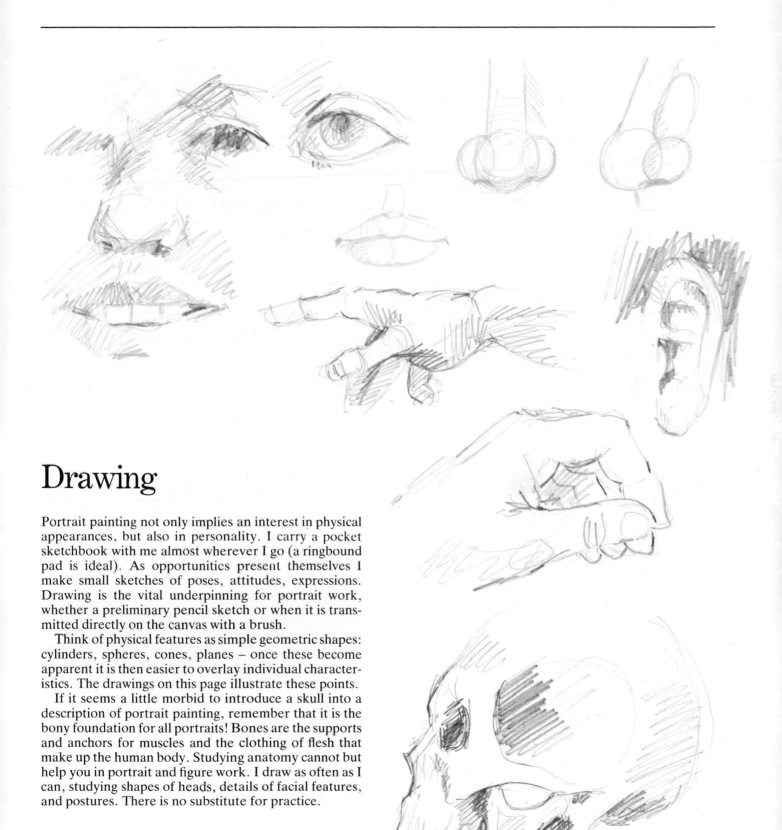

Drawing

Portrait painting not only implies an interest in physical appearances, but also in personality. I carry a pocket sketchbook with me almost wherever I go (a ringbound pad is ideal). As opportunitics present themselves I make small sketches of poses, attitudes, expressions. Drawing is the vital underpinning for portrait work, whether a preliminary pencil sketch or when it is transmitted directly on the canvas with a brush.

Think of physical features as simple geometric shapes: cylinders, spheres, cones, planes – once these become apparent it is then easier to overlay individual characteristics. The drawings on this page illustrate these points.

If it seems a little morbid to introduce a skull into a description of portrait painting, remember that it is the bony foundation for all portraits! Bones are the supports and anchors for muscles and the clothing of flesh that make up the human body. Studying anatomy cannot but help you in portrait and figure work. I draw as often as I can, studying shapes of heads, details of facial features, and postures. There is no substitute for practice.

Hands

Hands often form a vital complement to a portrait head. The hands on this page are in various attitudes of tension and relaxation and were drawn very quickly. My own left hand is often my model – and it can be reversed to a right hand if it is viewed through a mirror which inverts the image laterally. See also page 65.

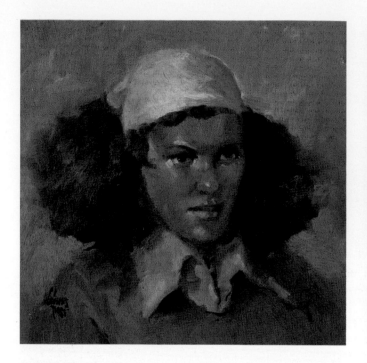

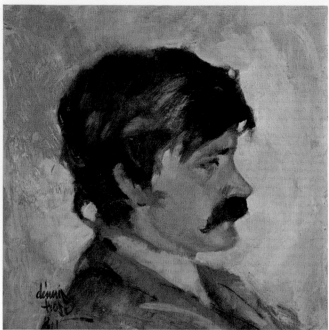

Gallery

Portrait painting is, to the observant painter, as rich a subject-matter as any. On this page and opposite four heads are illustrated: ranging from *Girl in the Straw Hat*, a sketch started and completed at a sitting of twenty minutes, through to the more finished portraits of *Young Girl with a Headscarf* and *Elderly Man with Beard*. From each of these I derived a different experience. Not only was my choice of colours different, but so was my approach to the way I tackled the depiction of my sitters.

Young Man in Profile and *Young Girl with Headscarf* use a muted palette, warm brown tones being dominant. Notice how all the dusky skin-tones in the girl's portrait relate to the white highlight of the scarf on the upper temple. With the young man it was his hair and moustache that provided the salient characteristics of his head, offering interesting shapes not so apparent had I seated him full-face on.

The sketch of *Girl in the Straw Hat* represents how one might use the human head as a subject without faithful reference to actual physical features. It is not so much a portrait as a freely executed exercise in observing light and shade and the resultant colours on skin, textures and related background. Such studies, while not being strictly portraits, can liberate a tendency to paint too lightly and cautiously. Many students, when approaching portraiture for the first time, make the mistake of worrying and overworking the picture, the result then often turning out to be flat and uninteresting.

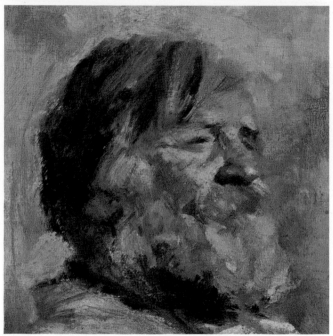

The vibrant expression of *Elderly Man with Beard* illustrates my point. With a freer technique and a more uninhibited palette with extra colours I felt I had succeeded in portraying the character of a notable local gentleman whose personality and vigour could best be captured by such an approach.

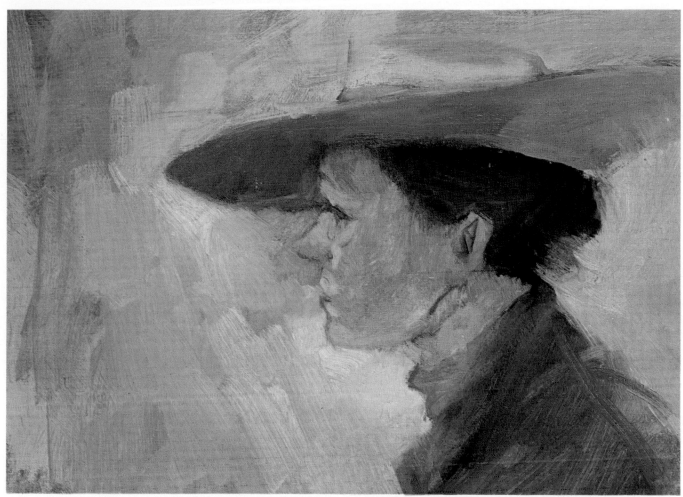

'Girl in the Straw Hat' (above). Below is a preparatory sketch for 'Portrait of a young man'. Opposite are the 'Gallery' portraits of 'Young Girl in a Headscarf', 'Young Man in Profile' and 'Elderly Man with Beard'.

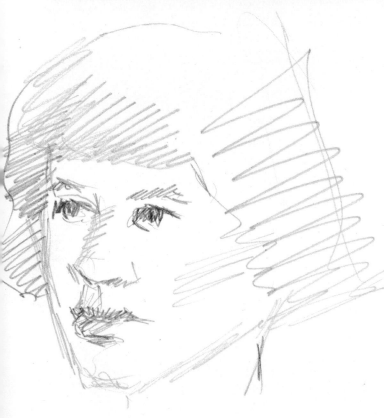

Portrait of a young man: demonstration

This is one of several paintings in which I used this young man as a model. I chose this demonstration to start with because of its cool colour range, thin paint and brevity of detail.

As a painter, one often feels a need to experiment with extremes of style. The usual pattern of progression in portraiture starts with a tight, photographic representation, and this is often followed by the desire to simplify the shapes and form to a minimum. There were many swings of the pendulum before I developed techniques that satisfied me and were acceptable to my clients. However experimentation is seldom wasted, for there will always be new subjects that require a different approach.

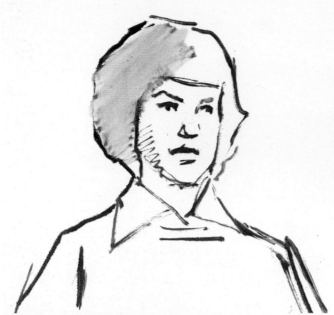

Stage 1

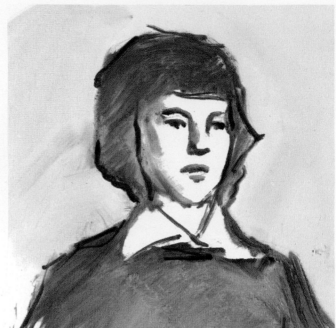

Stage 2

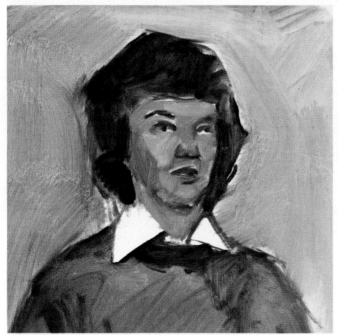

Stage 3

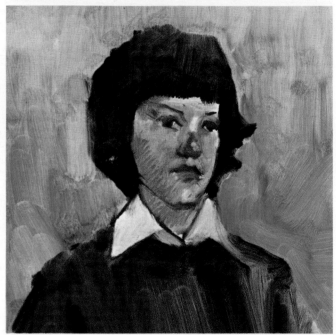

Stage 4

Stage 1

Using raw umber I placed the head and shoulders in an effective position on the board. The position of the features is indicated and a preliminary wash of raw umber worked into the hair.

Stage 2

The conversion of the line drawing into a tonal one is effected while the original paint is still wet. With a painting medium (half linseed oil and half pure turpentine) mixed with raw umber, some of the hard lines in the features are softened. Still working in raw umber, I paint

in the hair and jumper, then rub over with a clean rag to achieve a flat tonal effect, eliminating the majority of brush marks. The rag is then rubbed lightly over the background.

Stage 3

The whole face has now been reduced in tone, providing the foundation on which to build the tonal contrasts. Some of the darker areas are introduced into the hair and the jumper, and a thin wash of cobalt blue rubbed into the background. The paint is then allowed to dry before I proceed to the next stage.

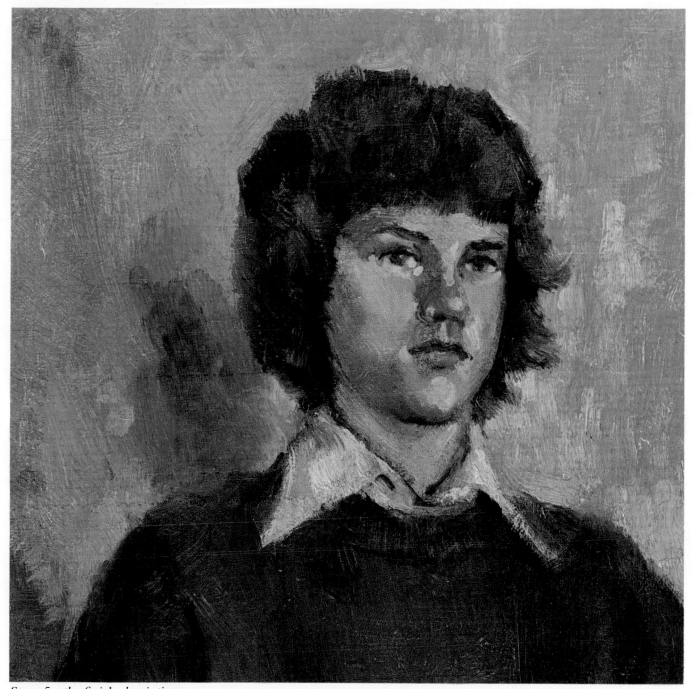

Stage 5 – the finished painting

Stage 4

When the paint has dried sufficiently to work on without lifting the underpainting, some colour is brushed into the face. Viridian and white are mixed for the shadows and a varying mix of alizarin crimson and cobalt blue used for the eyes. The flesh colours are achieved with cadmium red, yellow ochre, lemon yellow and white.

A little purple is placed in the background to echo the colour used in the face. The hair is darkened, and then the collar painted with flake white.

Stage 5 – the finished painting

Using a hog-hair filbert brush, and an absolute minimum of painting medium, the flesh colours are 'cooled' with a mixture of Naples yellow and Terre Verte. Cobalt blue, alizarin crimson and white produce the pearly greys used for the highlights around the eyes. The low key background is effected with Payne's grey and cerulean blue and the collar overpainted with cerulean blue to reduce its intrusive whiteness.

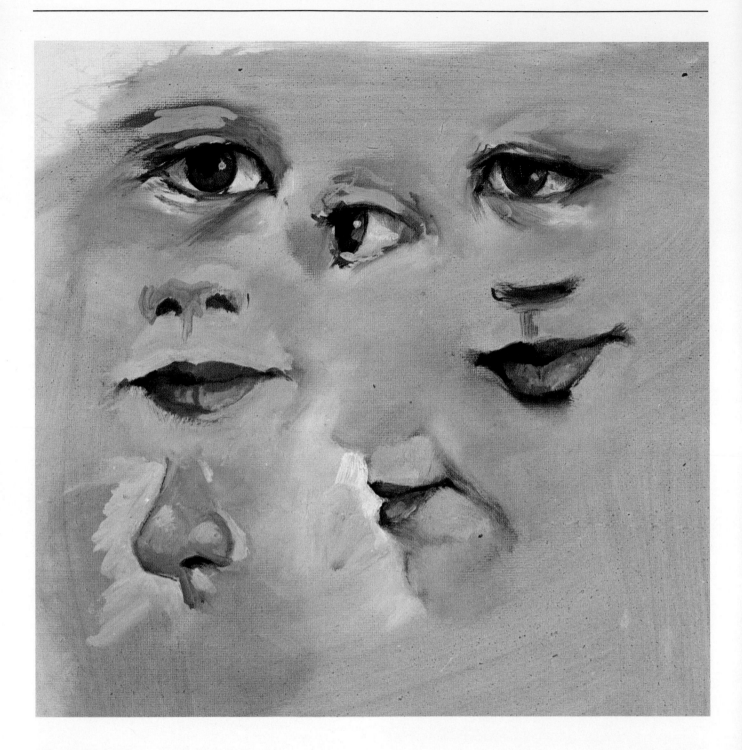

Painting features

Oil sketches of features such as eyes, mouths, hands, noses etc. not only help one to understand anatomy, they also provide an excellent means for studying tonal and textural differences.

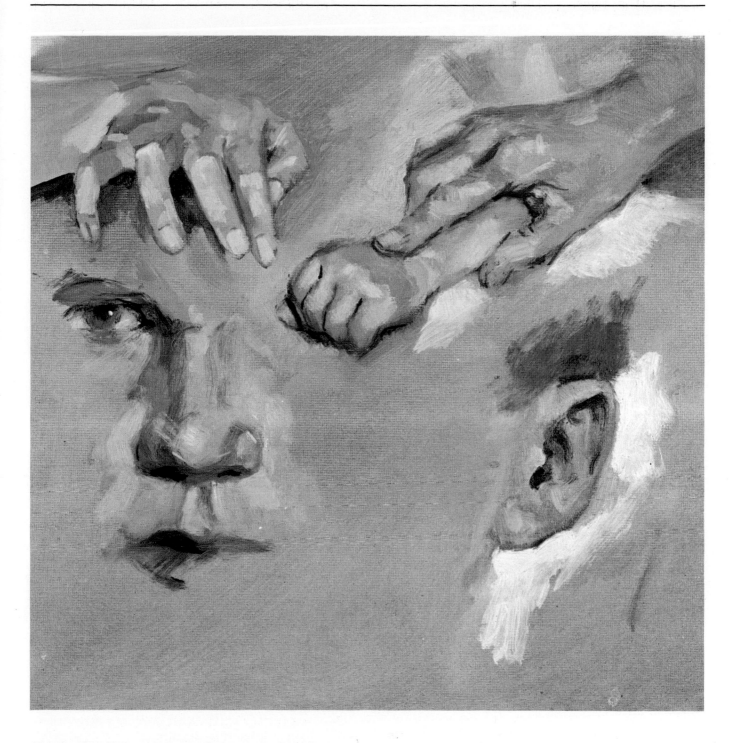

Hands often form a vital complement to a portrait head (above). See paragraph on page 59.

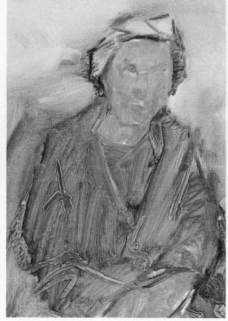

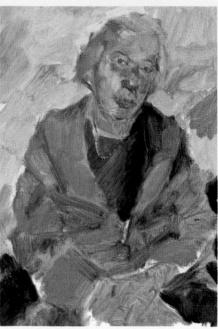

Stage 1 *Stage 2* *Stage 3*

The Necklace: demonstration

One of the pleasures of painting elderly people is that their personality and character show more clearly in their features.

What once were smooth contours have become weathered both from without and within by a lifetime of experience: happiness, sorrow, pain, illness, contentment, all can be read from the face, hands, and posture of the elderly. In this portrait the posture and the hands are as eloquent as the face itself.

Stage 1

The drawing was made with burnt umber mixed with turpentine and linseed oil in equal proportions, using a No. 2 hog bristle brush. A more diluted wash of the same colour was applied to cover the background and this was then rubbed over with a rag to give the board a flat covering which removed the original dominating white surface. This background colour will prove helpful when relating the tonal values (the darks and lights) in the early stages of the portrait.

Stage 2

With a No. 5 hog bristle brush, the flesh tones are now blocked in, using cadmium red, yellow ochre and flake white. The features are sketched in lightly with alizarin crimson, flake white and cobalt blue. I will keep the paint well diluted when I mix cobalt blue and yellow ochre to produce the green of the cardigan. A mixture of cobalt blue and ivory black is used for both the dress and the lower background.

Although at this stage the painting appears to be a shadowy impression, it is in fact the foundation for the whole picture in terms of colour and tone.

The picture is then allowed to dry before the next stage is started.

Stage 3

The paint is now thickly applied and the picture begins to take on a more solid form with the strengthening of colour and tone throughout the whole subject.

To echo the colour used in the figure, a combination of lemon yellow, cobalt blue, cerulean blue and white is used to paint the background.

The features are then defined, using alizarin crimson for the warm areas and cerulean blue and white for the cool areas.

Stage 4 – the finished painting

Practically the whole of the picture has now been repainted, giving it a more solid form.

The features are worked in. In an elderly person there are marked colour changes throughout the face, the areas around the eyes and nose are warm and the flesh will appear uneven and colourful, as opposed to the smooth and even flesh tints of youth.

The hands are painted so as to emphasise the fact that they are large, bony and arthritic. Some of the edges around the head and figure are softened to merge them into the background. This helps to give a feeling of recession and avoids the aspect of a cut-out figure.

After the addition of cadmium red and white to complement the flesh tones, the background is subdued in order to give dominance to the figure. Finally the necklace is painted in.

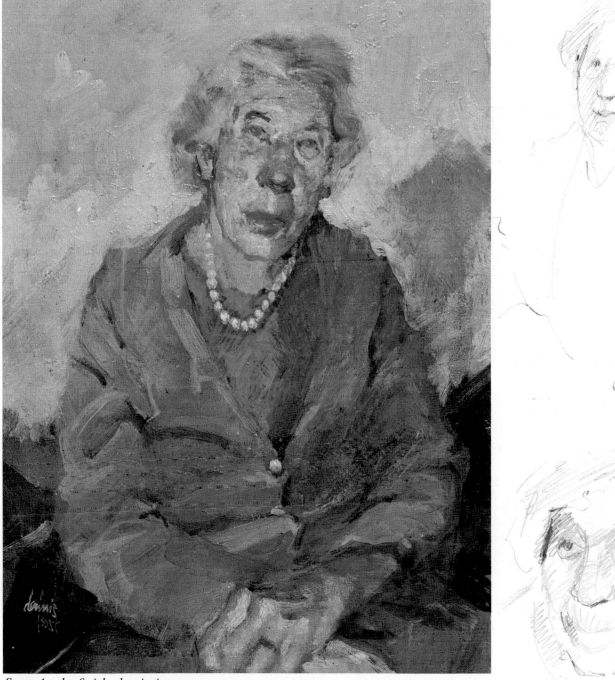

Stage 4 – the finished painting

David: Child portrait demonstration

Child portraiture will require all of your patience, and a different type of setting-up from that explained under *Preparation and Approach* (page 58).

You must be prepared for a child to be still only for very short periods, and you must mentally note the particular expression that appeals to you, and build up your painting of it each time it reappears.

Photographs can be a valuable aid when used in conjunction with the many sketches that precede an oil painting. You must also decide which style of work is most suitable for the sitter. I believe that an impressionistic style is not the most suitable for the very young: a simpler approach can capture the bright eye and smooth unlined skin to greater effect.

Stage 1 *(page 68)*

With a No. 2 hog-hair brush and using raw umber diluted with painting medium, the head and shoulders are drawn

Child portrait demonstration

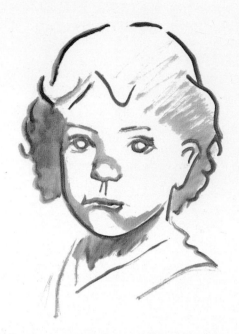

Stage 1

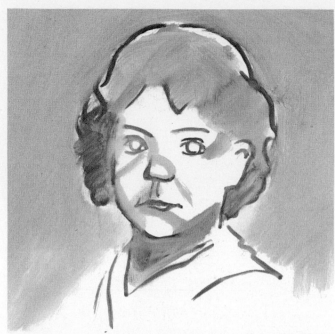

Stage 2

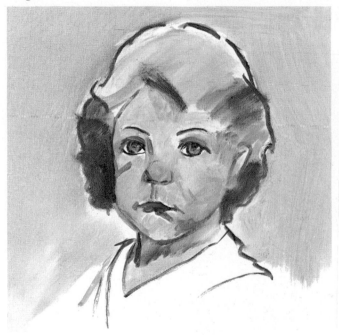

Stage 3

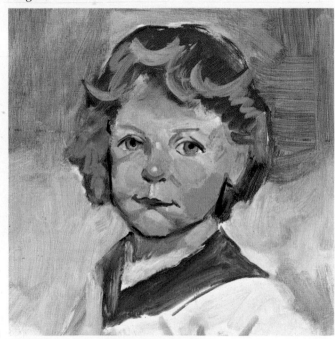

Stage 4

in and a thin wash of the same colour is introduced to state where some of the shadows will be.

Stage 2

More diluted raw umber is added to reinforce the tonal balance. The hair is blocked in and a little more tone applied to the face.

A diluted solution of Terre Verte is brushed into the background and then rubbed over with a clean rag, to give a flat area of colour which will complement the child's flesh tones.

Stage 3

The colours used to make the flesh tints are now added: yellow ochre, cadmium red and flake white. Burnt umber is used for the shadows in the face and cobalt blue and Payne's grey for the eyes. A little alizarin crimson is painted on the eyelids, and the shadows in the hair are deepened with raw umber.

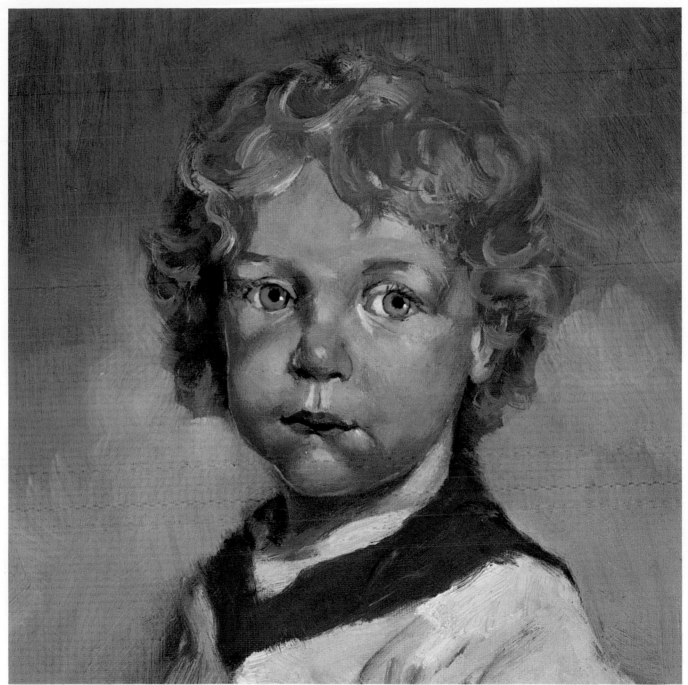

Stage 5 – the finished painting

Stage 4

At this stage the face is given greater detail. The shapes of the features are picked out in more definite terms and highlights added.

In order for me to achieve the effect I am seeking, a constant *paint and revise* technique seems the most successful means. From an early stage in the painting all parts must go forward together, no areas being finally completed whilst others are still in a preliminary stage.

Stage 5 – the finished painting

For the final painting of the flesh, a very little medium is mixed into the colours, and Terre Verte and flake white make a complementary background for this young subject. The wistful, detached expression so noticeable in childhood is achieved by making the eyes regard a point over my right shoulder.

The Feather Boa: demonstration

The opportunity to paint a portrait in costume is quite rare, and is all the more welcome when it does present itself, for costume gives the artist a chance to explore new and unusual textures. This actress had access to a theatre wardrobe and we tried several different costumes before deciding on the hat and feather boa.

Stage 1 *(page 71)*

The drawing is made with a No. 2 filbert hog-hair brush, using burnt umber. At this stage, although the shapes are drawn in sketchily they are, nevertheless, reasonably accurate and the composition is set within the boundaries of the board. Any slight mistakes can be corrected as the painting progresses to a more solid form with the introduction of shadows.

Feather boa demonstration

Stage 1

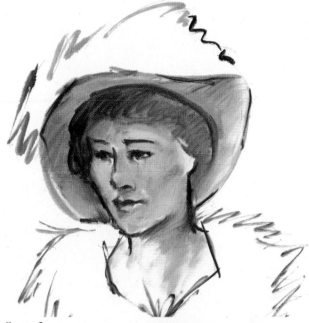

Stage 2

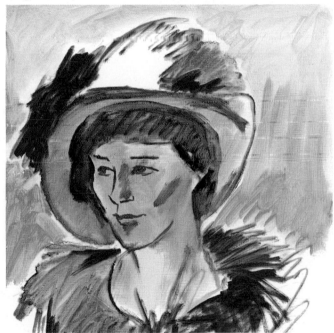

Stage 3

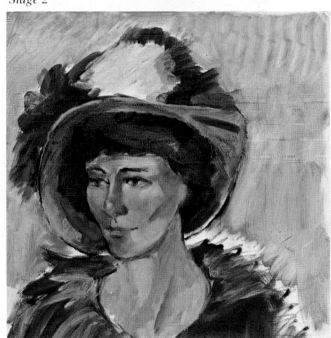

Stage 4

Stage 2

At this stage I confine the tonal areas to the shadows on the face and hair, and under the hat. Raw umber is applied with a brush, and then rubbed over with a rag to give a flat tonal quality free from brush strokes. The areas to be painted in bright colours are left unworked.

Stage 3

Still using raw umber, the tonal values are built up on the face and hair before the introduction of other colours.

Lemon yellow and cobalt blue are used in the background and the feathers blocked in using cadmium red, with alizarin crimson to give depth.

The paint is now allowed to harden before the work proceeds further.

Stage 4

The colours used for the flesh tones are yellow ochre, cadmium red and flake white. The dark areas in the features are suggested with a little burnt umber and cobalt blue. Cobalt blue is used for the iris and Payne's

71

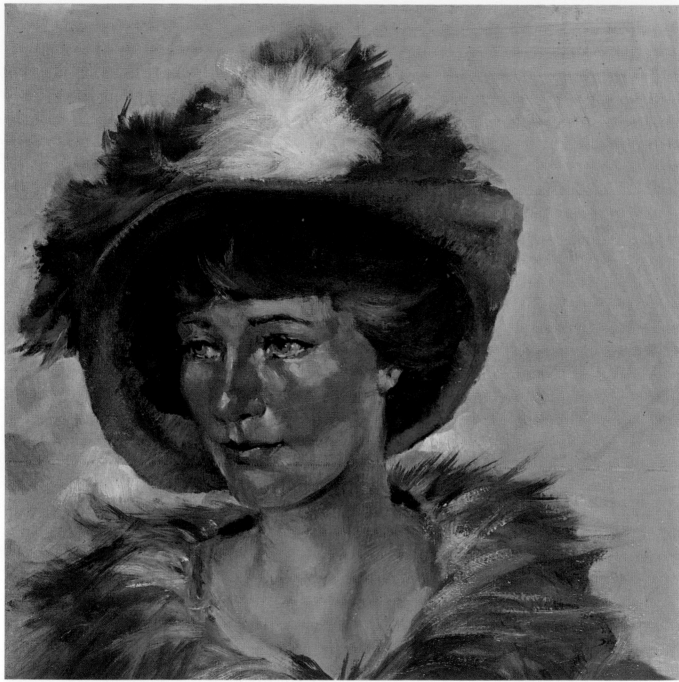

Stage 5 – the finished painting

grey for the pupils. At this stage the face begins to take on more form, not only because of the light and dark passages, but also because of the introduction of colour.

Apart from colour enhancing the form, one must always bear in mind that it will influence, and be influenced by the costume colours.

Stage 5 – the finished painting

The features by now are extensively modelled, with particular attention having been paid to the eyes. The general tone of the flesh colour is lowered, in order that it will be compatible with the shaded areas on the underside of the hat. The colour in the background is reduced in order to give more drama to the costume, and then the painting is left to dry again.

Once it is dry, I am then able to overpaint the features where they break into the background.

Some of the feathers on the hat are extra-downy and require a different approach; for this I use a sable brush.

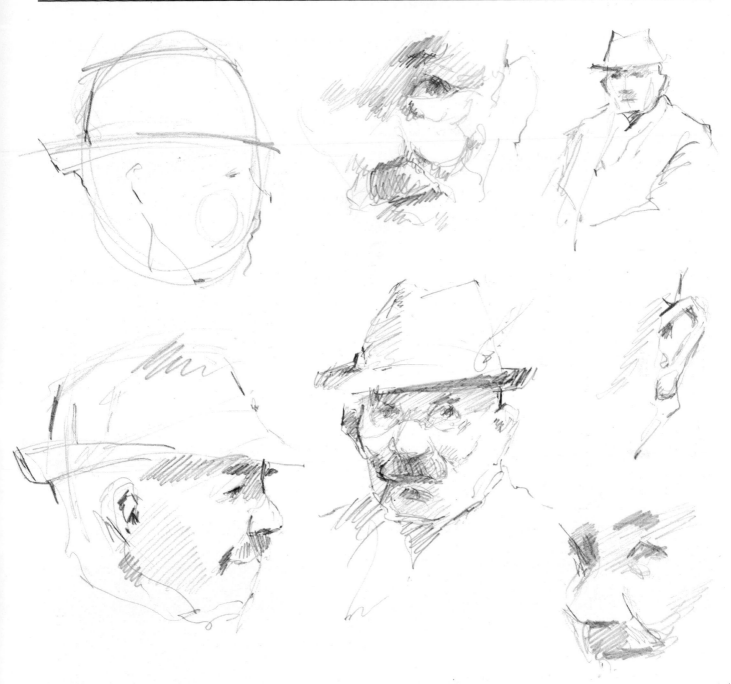

Len, a countryman: demonstration

Although this portrait was painted in my studio, I tried to achieve the impression of the outdoors, for Len is a groundsman at my local racecourse, and he spends most of his life out in the open.

Several preliminary drawings were made, from which I selected what I felt to be the most suitable position. Quick, thumbnail sketches can be invaluable in capturing the sitter's characteristics, without unnecessary details.

Stage 1 *(page 74)*

With my usual painting medium of an equal mix of pure turpentine and linseed oil, and using a No. 2 hog-hair filbert, I draw in the shape of the sitter lightly with raw umber, only a little attention being paid to detail.

Setting the subject in the most effective position on the board, with the proportions approximately correct, is very important at this early stage.

Stage 2

Using a light wash of raw umber, I convert the basic shapes into a tonal sketch. Once the outline or map of the subject is stated, I start to think in terms of solid form and this blocking-in of lights and darks gives the picture the beginnings of a third dimension.

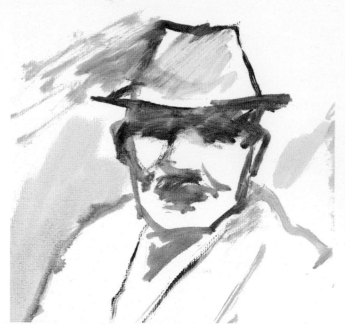

Stage 1

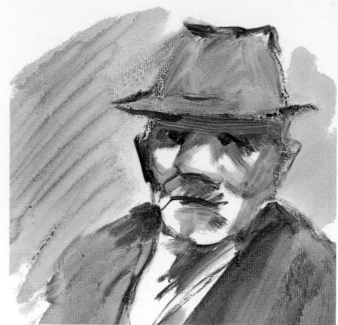

Stage 2

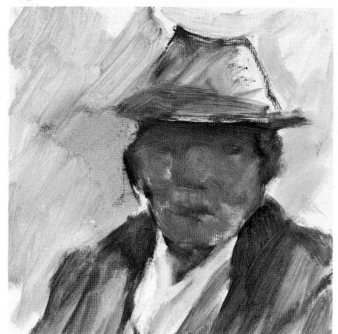

Stage 3

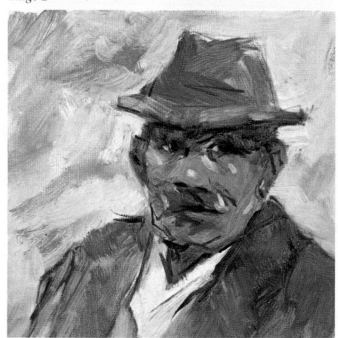

Stage 4

Stage 3

From the simple tone painting I progress to colour, keeping the painting very loose and working all the sections simultaneously. The flesh tones are made up from yellow ochre, cadmium red and flake white. Yellow ochre and cobalt blue are used for the green of the waistcoat, Payne's grey and raw umber are brushed into the coat.

Stage 4

At this point it is necessary to get more detail into the features. Some of the problems encountered when

trying to suggest prominence or recession can be overcome by the introduction of lights and darks.

Beautiful shades of purple can be achieved by mixing together alizarin crimson, cobalt blue and flake white. By varying the proportions of these colours you can produce a range of warm, cool or pale hues. I use a very warm mix to shape the shadows under the nose and lips and a predominantly blue mix for the shadows under the chin and hat.

To complete this stage, cerulean blue, lemon yellow and white are applied to the background.

74

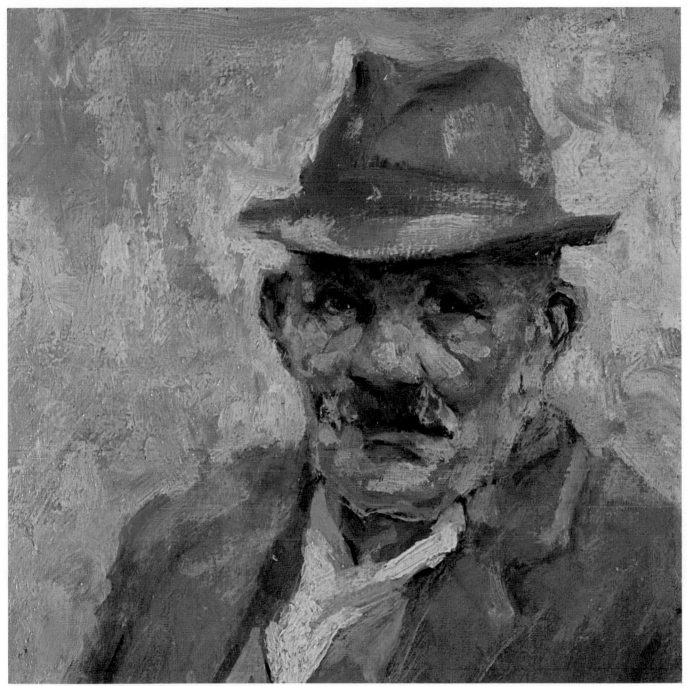

Stage 5—the finished painting

Stage 5 – the final painting

Most of the extremes of light and dark, and the more
extravagant colours, are now modified as I work towards
the completion of the portrait.

The old working coat and hat are darkened and kept
free of detail which in turn helps to emphasise the warm,
sunny lights on the face.

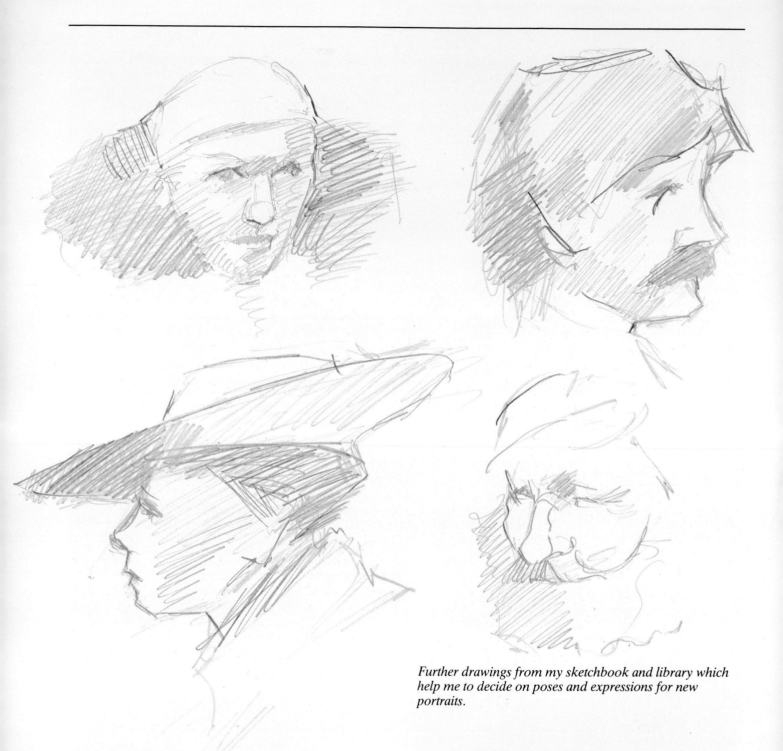

Further drawings from my sketchbook and library which help me to decide on poses and expressions for new portraits.

Using photographs

I am sometimes required to paint a portrait using a photograph as the only source. Photographs can be an extremely useful aid to the portrait painter providing they are used for information and guidance, rather than being slavishly copied; for any painting, be it landscape, still-life, or portrait, should reflect the artist's own skill and interpretation.

I rarely use photographs when the model is available, other than to record the setting and costume details,

which can be painted without the presence of the sitter. Nevertheless a photograph is an acceptable basis for painting a smiling face; also when I attend functions that attract large numbers of people – markets, fairs, or race meetings – I always take my camera with me. There are so many interesting faces to be seen which will provide inspiration for future paintings.

Most of my photographs are not taken in colour. This is not a matter of economics, but from choice, for I find that the limited amount of information provided in a black and white photograph encourages much more freedom of interpretation.

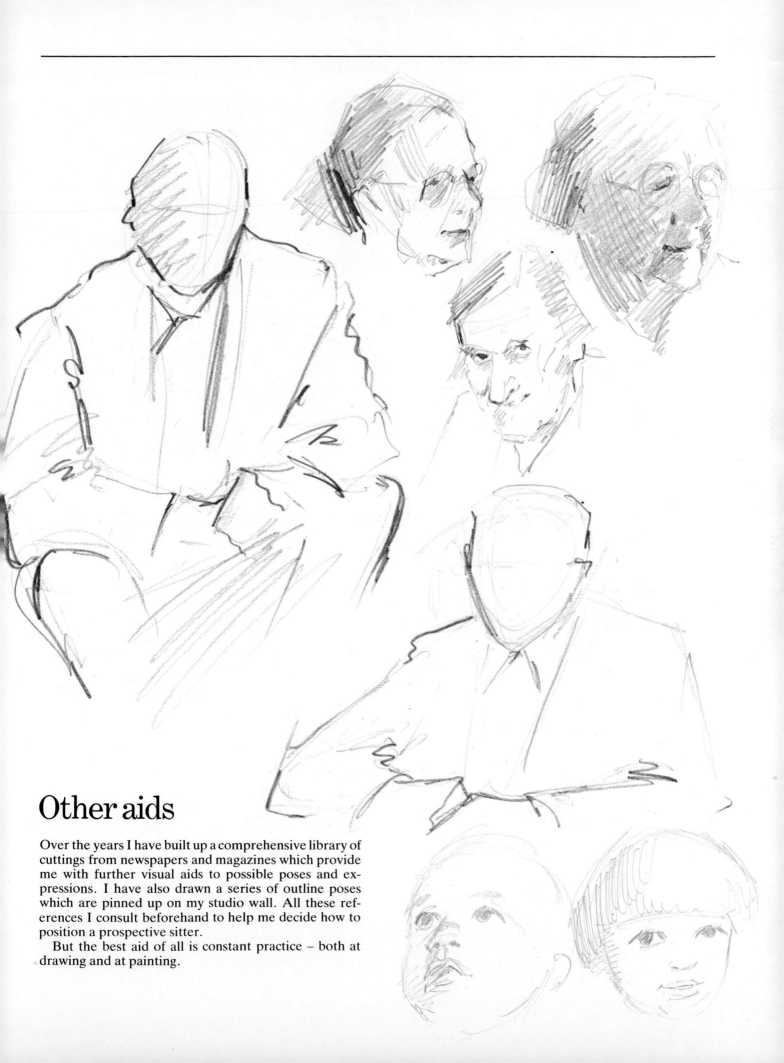

Other aids

Over the years I have built up a comprehensive library of cuttings from newspapers and magazines which provide me with further visual aids to possible poses and expressions. I have also drawn a series of outline poses which are pinned up on my studio wall. All these references I consult beforehand to help me decide how to position a prospective sitter.

But the best aid of all is constant practice – both at drawing and at painting.

Painting Flowers
by Norman Battershill

Introduction

Many artists enjoy painting flowers and feel a strong desire to capture their beauty on canvas. For them all flowers can be a source of inspiration, even the common dandelion. Its deep yellow petals suggest the summer sun, while the transformation of the flower into a puff-ball is a marvel of nature.

Every artist paints in a different way but understanding of tone, colour and shape is essential to any flower painting. A useful exercise is to draw parts of a flower when seen under a magnifying glass, or through a microscope. It is instructive, as a drawing on its own, or as a preliminary sketch for a painting; it also reveals a world of intricate and fascinating design and structure.

There are a few problems associated with painting flowers out of doors, for example, the difficulty of positioning yourself in relation to the flowers you are trying to paint, the fluctuating light conditions, and maybe a certain amount of discomfort because of the weather, but for all that it is most rewarding.

On several occasions I have enjoyed painting cultivated flowers in a greenhouse. The light filtering through glass makes an interesting effect. It is easiest, of course, to paint flowers in the studio, but remember that some flowers droop very rapidly and it is therefore best to paint the flower head first.

It is a constant temptation to pick wild flowers, but some species are now becoming quite rare and we need to conserve them and our countryside.

Drawing

When you are drawing flowers keep to a positive line and study carefully the way shapes are formed. It is not always necessary to add shading to your drawing, and indeed by keeping the drawing simple you develop surety of line. The drawings on this and the opposite page were drawn direct without any preliminary sketching in.

When you start to draw flowers it is preferable not to draw too many together as the result can be confused and over-fussy. Take just one flower and study it carefully. Turn it around in your hand and look at it from different angles. You could also cut a section of a flower, study it through a magnifying glass, and then draw the enlarged section. When drawing a detail like this it is better to draw larger than life size. If your drawing looks a bit clumsy at first, do not despair, just keep practising.

Drawing is a very necessary prelude to painting, but it is also absorbing and rewarding in itself.

Always try and draw as much as possible, and carry a sketchbook with you all the time.

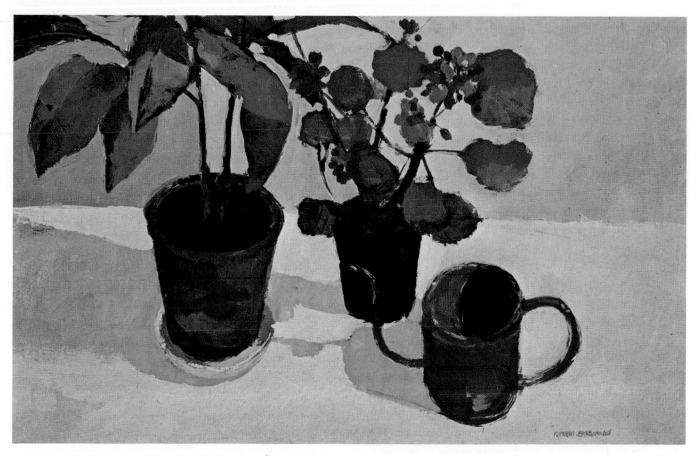

Geraniums. 508 × 762 mm/20 × 30 in. Oil on board.

Much of this painting is just a stain of colour, in particular the watering-can and the under-painting for the clay flower pot. Carrying the subject out of the top of the picture in this way can often create a more interesting aspect than always trying to keep it within the frame area. Notice how important the dark tones are in linking up the flower pots and the watering-can.

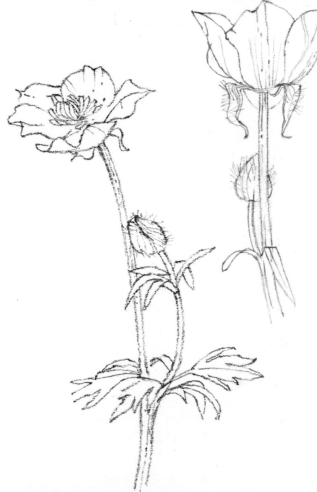

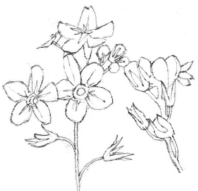

Pencil studies. Each drawing is 115 × 50 mm/4½ × 2 in.

Carbon pencil and 2B pencil on water-colour paper. The coarse texture of such paper makes a pencil line interesting. When you do a sectional drawing of a flower like this one of a dandelion, it makes you realize the beautiful intricacy of nature's geometric patterns and structures.

Painting from photographs

It is obviously better to paint real flowers but a photograph or a colour transparency can often provide an idea for a subject, or suggest a particular composition or lighting effect. But beware of painting a close copy of a photograph – after all, you are the artist and it is your impression that counts. If you are interested in making a detailed and accurate study of a flower, a photograph may not give you all the information and detail you need. Without your seeing the actual flower there is a chance that your painting of it may lack knowledge.

A good method of working from a photograph is to try to paint a loose impression of the subject. Put away the small brushes and use the largest you can in relation to the size of the painting. The photograph will most likely show clear defined edges to the nearest and furthest parts of the flower. If you soften the latter it will create more recession and atmosphere in the painting.

When painting flowers from a photograph be wary of putting in too much detail. Try a simple approach. Half close your eyes and look at the photograph. What you then see is the subject without detail or confusing middle tones. Try painting your flower subject like that.

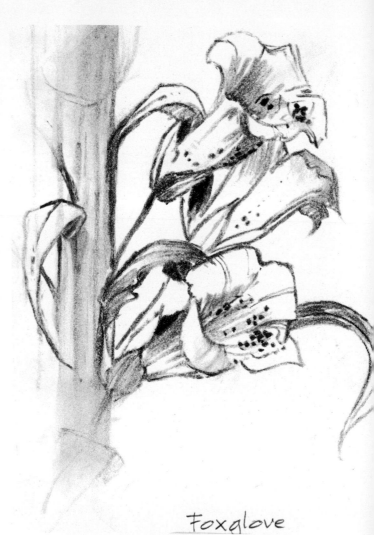

Foxglove

Foxglove. 152 × 102 mm/6 × 4 in. Charcoal.

For a change, draw part of a flower stem instead of the whole of it. This full-size sketch is part of a four-foot high foxglove. One point to remember is that charcoal cannot always be completely removed from some paper surfaces. The flower stem on the left of this drawing is not totally erased despite very firm pressure.

80

Flower colours

When painting flowers it is essential to know how to lighten or darken a colour without losing its character.

Try mixing black with the brightest and lightest colours in your box. Then start again by mixing white with the same colours. You will notice that black reduces colour to shades and mutes the colour to make it duller; while white lightens the colour to tints. A dark colour such as burnt umber has a similar effect to black but at the same time it adds a certain warmth to the colour. Remember too that a white flower is never white. There are always beautiful subtle tints of cobalt blue or pale pink or yellow in its petals. By adding tints of these colours you make your painting more vibrant.

Try not to mix more than three colours together; this way they will remain cleaner and fresher looking.

Here are a few flower colours to help you start. In the column on the right I have suggested ways of darkening a colour without using black or burnt umber.

Flower Colour	Mix for Shade/Colour
CADMIUM YELLOW	Violet
	Raw Sienna
CADMIUM ORANGE	Cobalt Blue
	Alizarin Crimson
	Cadmium Red
	Burnt Sienna
CADMIUM RED	Viridian
	Burnt Sienna
VIOLET	Ultramarine
	Alizarin Crimson
	Viridian
COBALT BLUE	Ultramarine
	Violet
GREEN	Alizarin Crimson
	Ultramarine
	Prussian Blue
	Burnt Sienna
PINK	Vermilion
	Burnt Sienna
	Cadmium Red

Golden Shower rose: demonstration

Size 152 × 152 mm/6 × 6 in. Oil. Sketching paper. Brushes: 4 and rigger. Colours: cadmium yellow, lemon yellow, ultramarine, alizarin crimson, cadmium orange, sap green, titanium white.

Stage 1 *(page 82)*

The rose is in a jar in my studio so I am able to work more easily than outdoors. I establish the darks first, using ultramarine and sap green with a mixture of alizarin crimson to produce the darker colour of the leaves.

After roughing in the main petal shapes I paint a thin stain of lemon yellow diluted with turpentine over the area of the flower. This gives me a base colour to work on and from there I start on the dark background.

Stage 2

I continue blocking in the background tones below the flower, making them soft in order to produce a lighter effect in the lower part of the painting. I make sure that the edges are not too well defined; any tightening up comes at a later stage. You can see how the background throws out the yellow. It also helps to establish the light and dark tones of the flower. A rose is complex so it helps to simplify shapes. I always look for the dark petal areas first, then indicate them with a mixture of cadmium yellow, alizarin crimson and a touch of ultramarine. After that I start on the lighter tones at the top of the rose. The bud on the right is painted with a mixture of alizarin crimson and cadmium yellow.

Stage 3

While the background is still wet I paint in more colour around the stem of the rose, mixing ultramarine and alizarin crimson for the dark purple. Lemon yellow and titanium white are used to suggest the lighter part of the petals. The brush marks are left undisturbed as much as possible. For the leaves I use a mixture of lemon yellow and ultramarine.

Stage 1

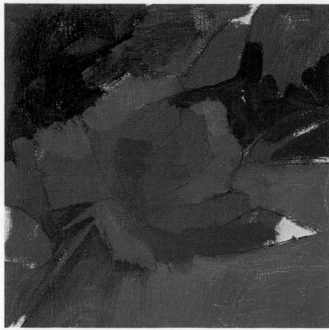

Stage 2

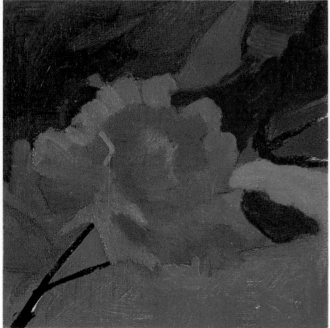

Stage 3

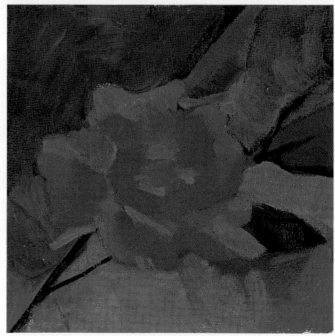

Stage 4

Stage 4

By this stage the painting has begun to come together but it still needs more work. For myself I feel it is unnecessary to paint with a photographic finish, although some artists do prefer this kind of realism in their paintings. The choice is a personal one.

The background has been softened by blending the colours while they are still wet to give the impression of recession. The colour behind the rosebud is a mixture of ultramarine, lemon yellow and alizarin crimson, with white painted in while the previous colours are still wet.

At this stage in the painting I start to emphasize the shape of the bloom by adding contrasting dark shadows of cadmium yellow, mixed with alizarin crimson and ultramarine. I make the rosebud colour a little more subdued as it is too dominant in Stage 3.

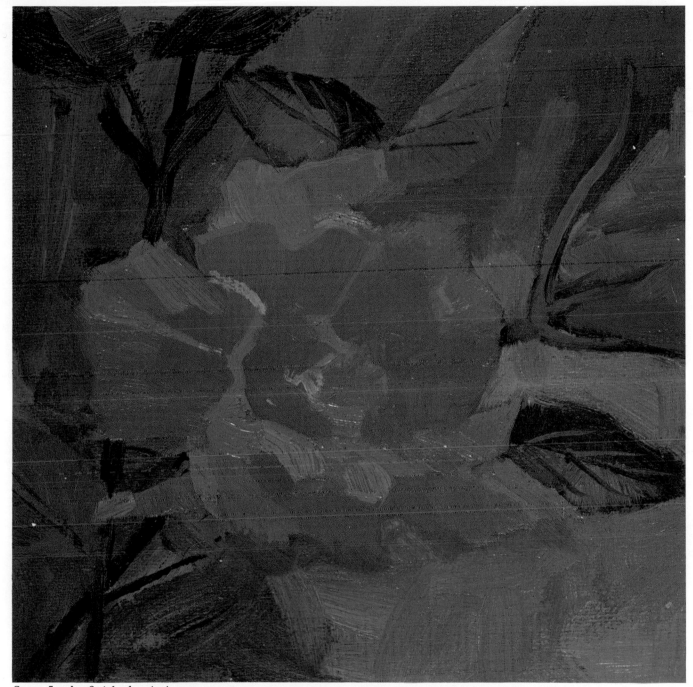

Stage 5—the finished painting

Stage 5 – the finished painting

With a fine sable rigger I put in some highlights on the petals, mixing lemon yellow with lots of white. If you apply the paint thickly in the direction of the petals you will give an impression of form and movement. The rose stem goes into the corner of the picture making a weak composition, so I 'pull it over' by adding further stems. I also add light colour to the rosebud and define the leaves. I then put in more foliage at the top of the painting to create a better balance of composition.

With a clean dry brush I drag some of the petal edges to give a softer effect.

Palette used for the Golden Shower rose on page 83.

The palette is divided into two areas of light and dark colours. This ensures that they stay cleaner. It is also a good idea to keep brushes for light colours separate from brushes used for dark colours as this also helps to keep the colours clean. You can see that the colours are not completely blended so that texture and interest are enhanced.

Golden Shower. 152 × 127 mm/6 × 5 in. and 76 × 76 mm/3 × 3 in.

By following the surface lines of the petals you are more likely to understand their shape. You can begin a pencil study with just an outline and leave it without any shading.

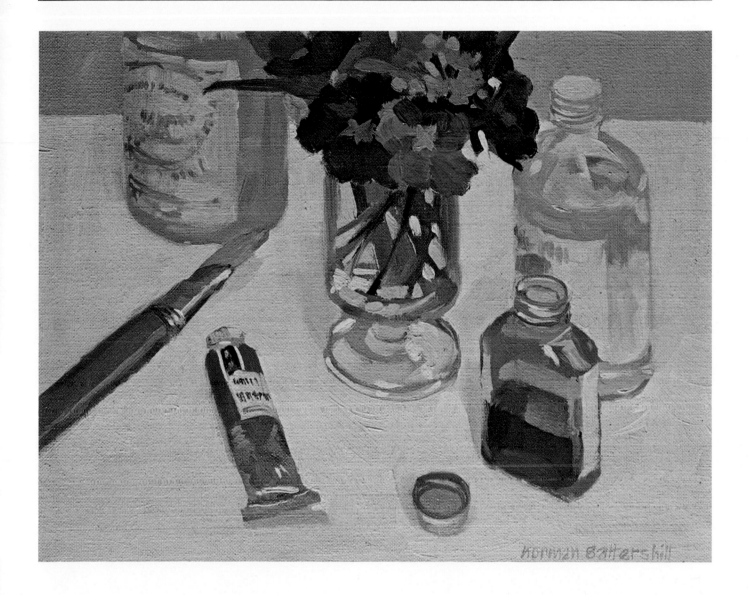

Still life. 305 × 254 mm/12 × 10 in. Oil on canvas on board

The flowers are in the centre of the painting but this does not upset the total composition. A triangular balance of tone is achieved by the colour of the tube of paint, the darker bottle on the right, and the flowers.

Still life

A very interesting approach to flower painting is to include other objects and make a still-life group. My painting on this page of flowers in a glass of water includes a bottle of turpentine, a bottle of painting medium, a tube of paint, a paint brush and a marmalade jar. Incidentally, I painted the flowers first before they had time to droop.

Personally I think a still-life group is often best if the objects are related. But when you are setting up a still life try to avoid a contrived arrangement. Lay the objects down freely and resist the temptation to arrange

them – let it be a bit haphazard. When you have finished the arrangement, try and take something out of the group without spoiling the composition. This is a good test to see if it is balanced.

You can make a painting of the breakfast table, with a vase of flowers, cups and saucers, packets of cereal and a teapot. The possibilities are endless, but try a simple arrangement to begin with. The kitchen offers the greatest variety of subjects for a still life, with vegetables, fruits, pots and pans, packets and tins, and many other interesting items.

A vase or bowl of flowers on a highly polished wooden table is a traditional subject, which offers a rich contrast of tone and colour. Another classical flower subject is a single flower in a vase or glass of water. Although this is a basically simple subject, it is the complexity of different light patterns and shapes seen through the glass and water that provides the interest.

When selecting a vase or receptacle for the flowers, choose one that is not too ornate, or it may dominate the painting and detract from the flowers.

A still life does not have to be arranged specially. Draw whatever is on the table. My sketch is in sepia Conté pencil.

Flowers in a vase: demonstration

Size 254 × 254 mm/10 × 10 in. Oil on canvas board. Brushes: 6 and 4 long flat bristle, and nylon rigger. Colours: cadmium red, cadmium yellow, yellow ochre, alizarin crimson, cadmium orange and titanium white.

Stage 1 *(page 87)*

I roughly draw in the main shapes with yellow ochre and then establish the areas in a basic colour. My main concern in the first stages of the painting is to fix the tone values. There are four areas that form the basis of this composition. The most important of these is the arrangement of the flowers and the positioning of the vase. Then comes the baseline and the vertical line on the left.

For the background I have made the left-hand side a cool blue grey and the right-hand side a warm pink. This gives a contrast between cool and warm colours. At a later stage I may modify this.

Stage 2

I look for dark colours and begin to establish these in the flowers and the base. I keep my brushwork as broad as possible and do not overwork the paint. Detail always comes last, so I look only for main shapes and general colours. I have already decided that the table top is going to be a rich colour. For this I mix ultramarine and alizarin crimson, a touch of cadmium red, and white.

The background is much paler and therefore contrasts with the table top.

It is easy to become confused by a profusion of detail when painting flowers. Simplification in the early stages of your painting can add breadth of expression.

Stage 1

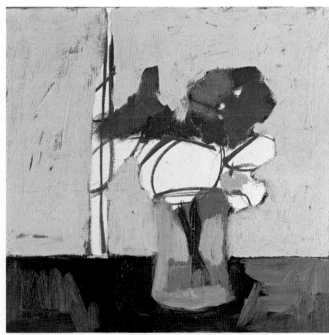

Stage 2

Stage 3

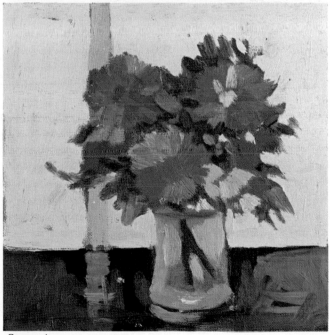

Stage 4

Stage 3

Now that I have worked out my basic colour scheme I start developing the flower shapes and the contrast of light and dark. For the part of the flowers in shadow I use a darker version of a colour, i.e. for the light part lemon yellow and cadmium yellow; for the dark part cadmium yellow and cadmium orange, or lemon yellow and yellow ochre.

Notice that there is not a predominant bloom right in the middle of the arrangement. A centrally placed flower would cause too much focal interest.

Stage 4

The painting is now coming together. As I prefer not to overdo the detail I keep the brushwork bold. If you compare this stage with Stage 3 you will see that I am now adding smaller brush marks of colour. By adding these now the flower heads become more clearly defined. I do not want a strong contrast between the light and dark of the petals but a contrast which is subtle.

I always enjoy painting the detail of flower stems in a vase. However, like the flowers themselves, stems in water must be simplified. It is also essential to determine the direction of the main source of light.

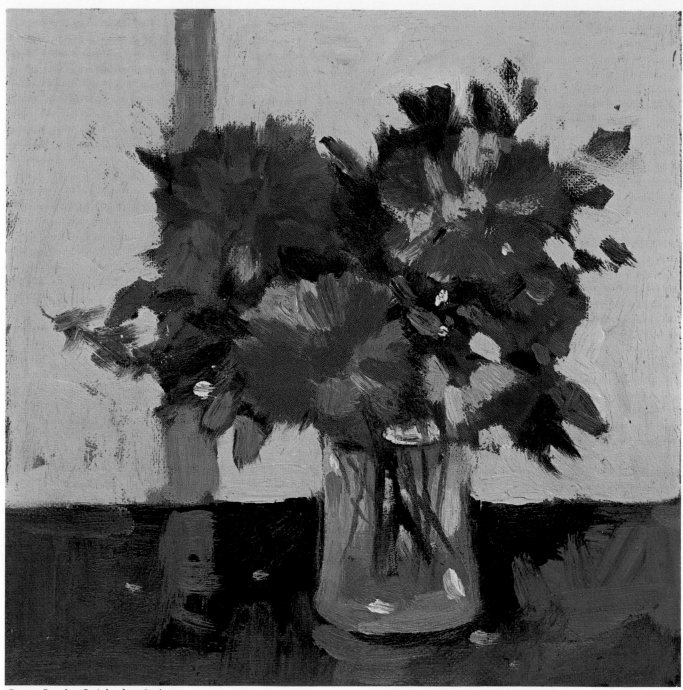

Stage 5—the finished painting

Stage 5 – the finished painting

It is only at this stage that I use the thin brush for adding touches of detail. To give a better balance to the composition I add more leaves to the group. In the previous stage there is a bit too much background. Including more leaves helps to create further a dimension between the flowers and the background.

The finished touches are kept to a minimum in order to retain the bold approach. I add a few more flower

stems to the vase and highlights on the glass. Do keep highlights to a minimum, though, because too many are distracting.

I soften the edge of the overall shape by adding some smaller leaves to the outline. I resist the temptation to go on adding detail and decide that the painting is finished.

Composition

It is best to have as natural a setting as possible, so try not to arrange a composition which looks too contrived. For example, avoid painting foliage pointing towards the corners of your painting as this takes the interest out of the picture. Similarly, although a single flower may be a focal point in a painting, it must not lead the eye too much away from the group.

Sometimes it is very effective to carry flowers or foliage right out of the picture, instead of always trying to ensure that everything fits exactly into the picture area.

Be selective when you are setting up a flower arrangement. A simple group of flowers may well be more interesting than a complicated and fussy bouquet. But do not give a variety of different flowers equal emphasis either, as this may make the painting rather monotonous. Another suggestion for an interesting composition is to place the flowers near a window in a direct light, thus giving a strong contrast between dark and light.

If you are uncertain about the arrangement make several rough pencil sketches before you start painting. This will help you to compose your painting properly. It is also a good plan to try and see the flowers and leaves as abstract shapes and colours before you begin to paint them. If you find this difficult, half close your eyes and you will see that the subjects are reduced to basic patterns.

Mixed flowers: demonstration

Size 178 × 178 mm/7 × 7 in. Oil on fine grain canvas. Brushes: 4, 6 and rigger. Colours: Prussian blue, cobalt blue, ultramarine, cadmium red, cadmium yellow, cadmium orange, cadmium lemon, alizarin crimson, titanium white.

Stage 1 *(page 90)*

I block in a rough outline with a pencil. I normally do this with a brush and thinned paint but for this demonstration I use a pencil. If you start your painting with a lot of turpentine the pencil lines become dirty. My method here is to paint direct with solid colour. I paint the darks of the leaves first and it does not matter that these colours may be too dark for the final stage of the painting – it is always best to begin the painting with bright rich colours.

Stage 2

The general pattern is built up without regard to the detail. The dark colours are painted first with sap green and ultramarine. In order to keep the colours rich, avoid mixing a lot of white. The red flower is created by a thin stain of cadmium red.

Stage 3

Sometimes the background can be left until last, but for this particular painting I rough it in now. Using more white in the mixing makes the colour opaque, so try not to push the paint around too much and thus keep the shapes bold and crisp. You can see how the pattern of colour is building up like a mosaic. I would suggest that you consider using this method for your next flower painting. You may find by making a study too life-like you have lost the essence of the subject.

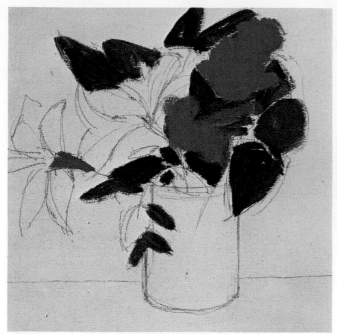

Stage 1

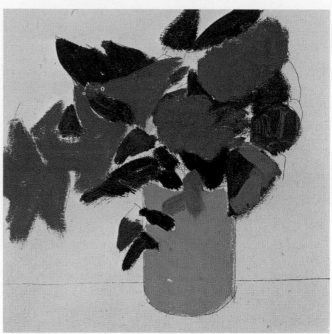

Stage 2

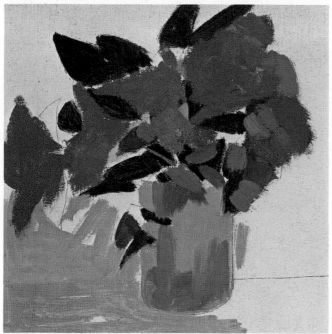

Stage 3

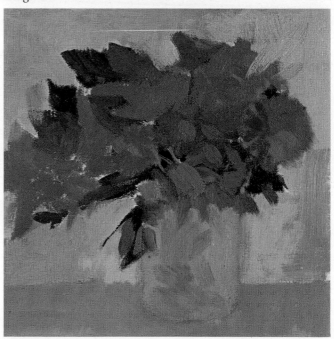

Stage 4

Stage 4

Now the complete pattern is beginning to emerge. Smaller accents of colour are added to the painting, which is still broad in treatment. Over the biscuit-coloured pot I paint a grey mixed from cobalt blue and cadmium red, with a touch of yellow. For the dark green I mix Prussian blue and cadmium yellow. Cadmium red and white mixed together are used for the lighter petals on the red flower.

I have decided that the mauve in the previous stage of the painting is not what I really want, so I paint over it with a solid application of paint mixed from lemon yellow and plenty of white.

The dark green foliage is now added and this forms a contrasting background to the flowers.

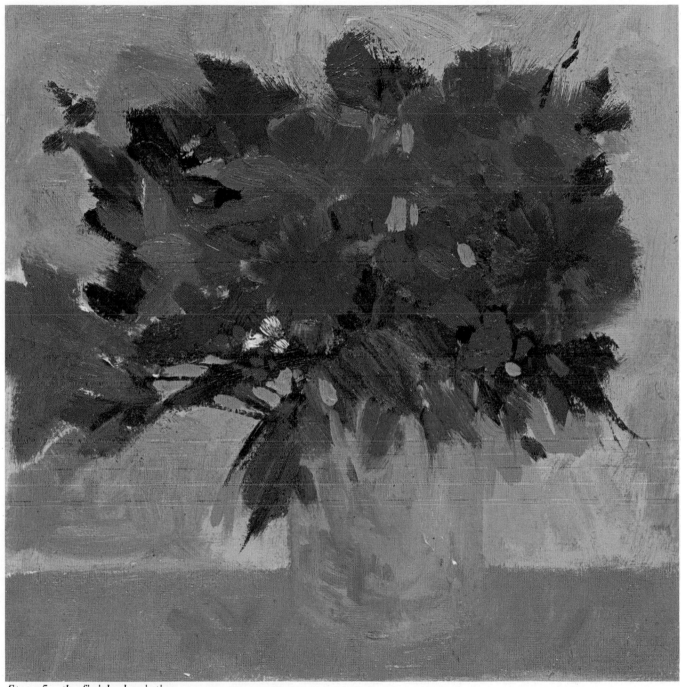

Stage 5 – the finished painting

Stage 5 – the finished painting

Here and there I soften the edges of the paint with a dry
clean brush in order to avoid hard outlines. Prussian
blue and cadmium lemon mixed together make a rich
light green colour. Notice how some of the flower
colours are repeated; this harmonises the different
patterns of colour. By adding a few lines on the left-hand
side to suggest stems there is a contrast between the solid
masses of colour. It is tempting to add yet more detail
but I want to keep this study very simple.

Painting outside

Painting flowers in the garden, or in the woods and fields, gives the artist the opportunity to find a wide variety of subjects. Flowers in the foreground with a house in the background, often used as a composition in a painting, provides numerous interesting possibilities.

It is better to do some sketches of your composition before you begin painting to make sure that you are satisfied with the arrangement of the overall design. A small corner of the garden may have more interest than a large flower border, or you may come across an everyday view, such as looking through the open door of a greenhouse.

Painting a mass of different flowers and leaves is not easy. Simplify as much as you can and avoid unnecessary detail. Choosing a few flowers against a dark background, such as a fence, makes an interesting contrast of light against dark.

A garden shed offers a very 'paintable' variety of subjects such as flower pots, seed boxes, watering-cans, and garden tools. If you paint for too long on a sunny day remember that light and shade will change quite quickly. Try to avoid altering your painting once you have firmly established the contrasts of light and dark.

Convolvulus: demonstration

Size 254 × 254 mm/10 × 10 in. Oil on canvas board. Brushes: 4 and 6 bristle and 2 rigger. Colours: violet, cadmium red, alizarin crimson, cobalt blue, ultramarine, cadmium yellow, lemon yellow, light red, titanium white.

Stage 1 *(page 93)*

Convolvulus is a fragile flower that does not like being picked from the hedgerow: it only lasts for a very short time indoors. To make the flowers stand out in this painting I first establish the background with a dark band of ultramarine mixed with cadmium red. I then stain the lower part to give a ground colour to work into. Because the colour is only mixed with turpentine and kept thin the roughing-in lines are still visible.

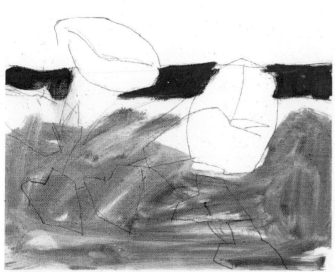

Stage 1

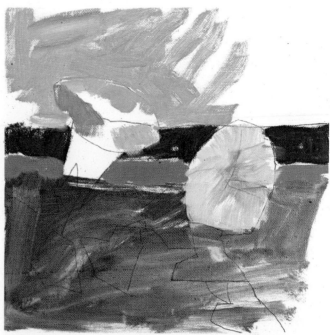

Stage 2

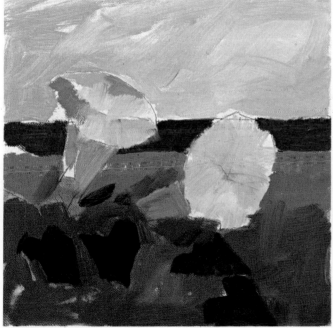

Stage 3

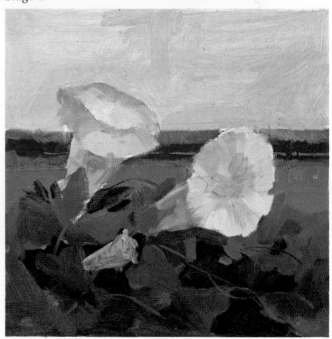

Stage 4

Stage 2

For the sky I mix cobalt blue, a touch of cadmium red and lots of white. The green is mixed from lemon yellow and ultramarine. When you are painting delicate flowers like the convolvulus it is best not to spend too much time on other parts of the painting, so I begin to block in the shadow colours of the flowers.

Stage 3

Next comes the dark green and some pastel tints for the flowers. Violet, a useful colour for flowers, is mixed here with cadmium red and cobalt blue. The dark band of blue on the horizon is too assertive, so I will tone it down in the next stage.

93

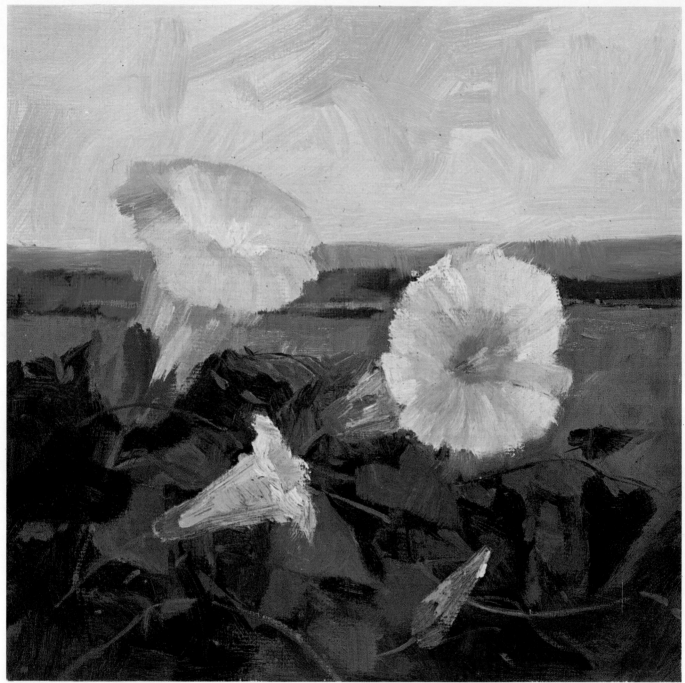

Stage 5—the finished painting

Stage 4 (page 93)

By adding a paler colour above the dark band I create an impression of recession. Now I start to give the flowers some shape and add detail to the greenery. I want to keep my painting broad in treatment and only use the rigger brush for the final touches. The foliage is now developed a little bit more by adding some dark colours and light contrast.

Working on the stained ground is a great help, not only in making the painting progress quicker, but also in providing an overall tone of colour.

Stage 5

The painting is pulled together by giving more form to the flowers and by adding a few touches of detail here and there.

With a clean dry brush I soften some edges of the flowers. The smaller flower is emphasized so that the composition is more evenly balanced. To suggest a distant cornfield, I use the sunny field colour and dry-brush it across. I sharpen the tones in the foliage and also add a flower bud to give a better balance to the composition.

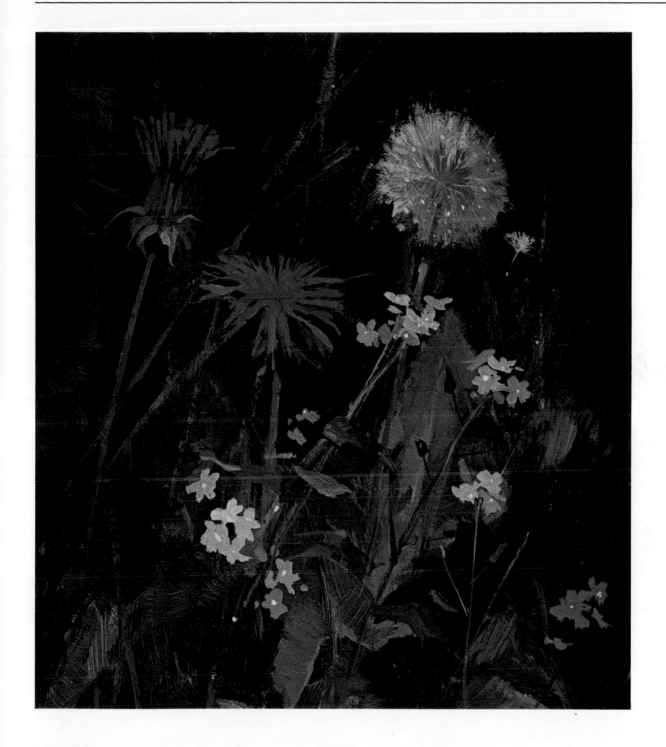

Puff-ball. 304 × 229 mm/12 × 9 in. Oil on canvas on
hardboard.

*The dandelion puff-ball and its ultimate seed flight is a
delight to observe and paint. I begin by laying-in a dark
background of ultramarine and cadmium yellow with a
touch of light red. Establishing the background first is
essential when there are light colours in the painting such
as the dandelion and the puff-ball.*

*When you set up flowers in the studio it is much better
to begin with just a few rather than a mixed bunch of many
different varieties. Notice in my painting here that the
emphasis is on one flower, which acts as a focal point,
but the rest of the painting contributes to the balance of
the composition.*

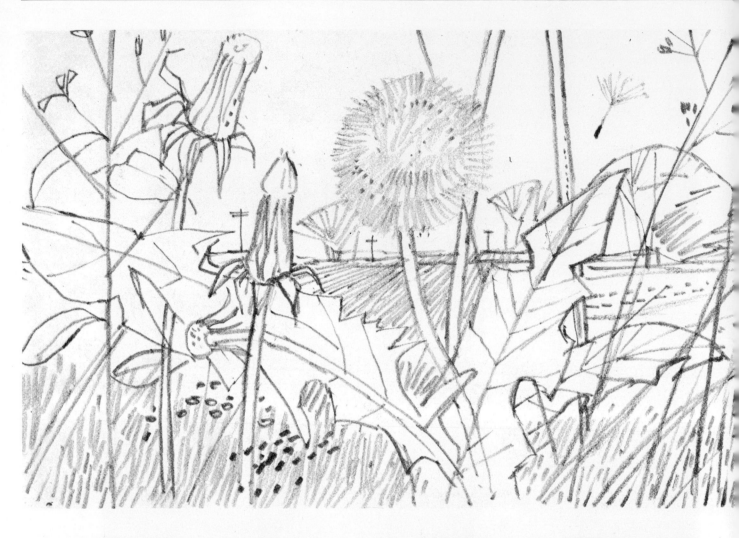

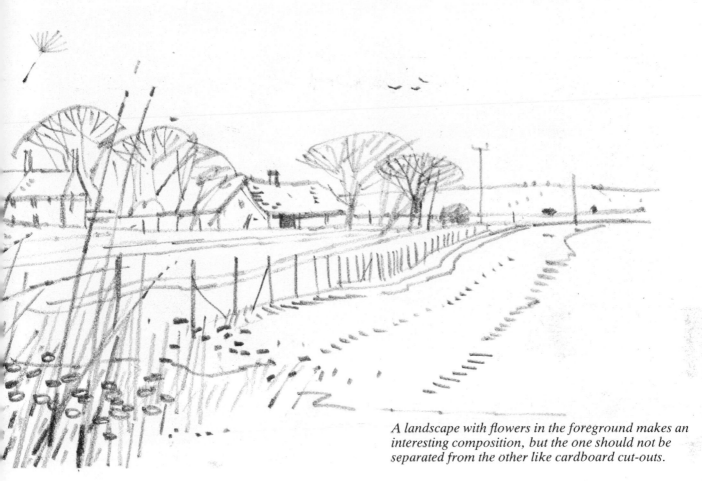

A landscape with flowers in the foreground makes an interesting composition, but the one should not be separated from the other like cardboard cut-outs.

Backgrounds

Backgrounds should not be obtrusive and must harmonise with a flower subject. Generally a darker background is chosen for pale flowers, and a lighter background for dark coloured flowers. But it is not always necessary to place too much emphasis on the contrast between the flowers and the background.

A mass of detail needs to be simplified. For my charcoal drawing I have used a snapshot taken in a garden to show you a method of simplification. The technique is similar to oil painting because I apply a stain all-over, then wipe out the sunny parts. Darks follow to establish shadows.

You can sometimes mix a suitable colour for the background by blending all the colours on your palette. The result is not always successful, however, because too many colours may have been mixed, resulting in a muddy grey, so I suggest you experiment with the colours suggested in the Flowers colours section (page 81).

Painting one side of the background lighter than the other gives it interest simply because it is not the same tone all over. If you blend part of your flower subject into the background it can be effective; similarly if you add some colour from the flowers into the background colour it increases the harmony.

In all these painting demonstrations I have aimed to show you how to paint some suitable backgrounds and at what stage to paint them. Sometimes I paint the background last, because in that way I can make it blend more easily with the main subject. If you are in doubt about the background colour you have mixed, paint the colour on to a separate piece of paper and hold it up against the painting. You can then judge the effect before actually painting it. Finally, it is better to scrape off a wrong background colour than to paint in the hope that it will eventually come right.

97

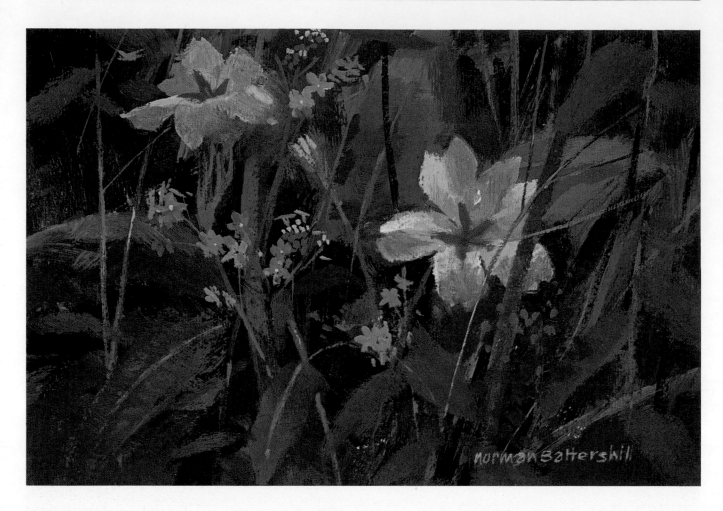

Primroses. 254 × 127 mm/10 × 7 in. Oil on canvas on
hardboard.

*The most important aspect of painting flowers against a
background is to ensure that they are part of it and not
separated from it like a cut-out.*

*Recession is as important in a small area like this as it
is in landscape painting. The blue forget-me-nots add
small touches of colour against the larger shapes.*

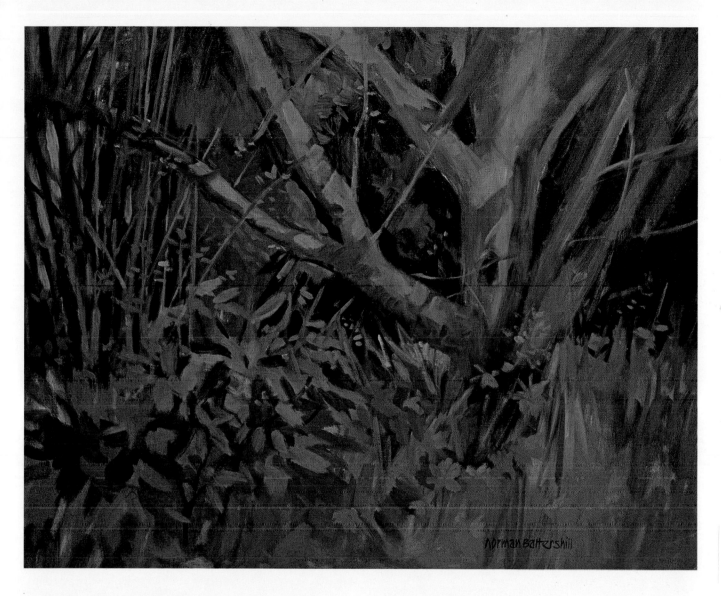

Daffodils. 762 × 610 mm/30 × 24 in. Oil on canvas.

I painted this out of doors in three hours, and I was lucky because everything went well, but it does not always happen like this. I was interested in the play of light and *shade and the way that the daffodils added golden spots of colour in a low-tone subject. You will notice that none of the daffodils is well defined; also that, because all the edges are softened, they do not become too dominating.*

99

Painting Boats and Harbours
by Clifford Bayly

Introduction

Boats and harbours are two of my favourite subjects. I have lived and worked near the sea for many years and have absorbed an abiding interest in and fascination with the visual qualities that exist in the panoramas and even in the bric-à-brac which are always associated with it.

Of all the natural elements the sea is the most powerful in leaving its mark on everything with which it comes into contact. It influences the appearance of other natural materials such as sand, stone and wood by shaping, colouring, eroding and bleaching. Its effects upon man-made materials such as metal, paint and rope add texture and character even by virtue of its corrosive and abrasive action. In studying and painting boats and harbours an appreciation of the visual qualities of these various materials is essential. I would encourage the reader to draw and paint on the spot as much as possible. I know it can be very inconvenient – particularly with incoming tides and blowing sand to say nothing of the occasional pungent smell of fish! Keep your painting gear to a minimum but take the precaution of using a small folding seat or stool and if possible a light sketching easel as it is difficult to work satisfactorily whilst sitting on wet sand or cold rocks.

Although we are concerned principally with the painting of boats and harbours it is essential that the context in which they exist is authentic and supports the character of the subject. I should add, in this connection, that in this book I am relating boats and harbours to the sea rather than to rivers or lakes, but either way the same principles apply.

On the subject of painting boards, I always prepare my boards with a ground according to the texture I wish to cover. This is usually brushed on in an acrylic primer.

Know your subject

Boats

To paint boats satisfactorily you need a basic knowledge of their form and function. There is no better way of gaining this than by drawing them at first hand. Look carefully at their construction as this will help in setting up the basic shape: for example, the line of the keel, whether flat or curved (that is if the boat is out of the water), the line of the gunwale or top edge of the sides. Check the proportion of beam (width) with the length, the angle of the bows (sharp end) etc. It is useful to draw a side view, back view and, if possible, a plan view first to establish the overall form before attempting the three-quarter view.

Although knowledge of boats and their rigging helps to give authenticity to your work remember that too much attention to accuracy and detail can make your painting appear sterile. Try to capture atmosphere and mood and let detail remain subservient to the overall quality of the work.

Harbours

It is not possible to cover the wide variety of harbours that exist – marinas, ports and docks. You will find that I have kept, in the main, to the smaller fishing harbours with which most of us are familiar and which present a wealth of paintable subjects.

The materials with which most harbours are built present many different textural qualities which are worth some practice to represent effectively: stone slabs, rough stone, timber supports, cast concrete to name but a few. The variety of construction, particularly the methods of laying stones, is worth study. It varies with the locality of course – depending upon the material available and local methods of building.

Subsidiary elements such as harbour lights and 'furniture' sheds, small buildings, nets, fish-boxes and other marine gear lying about, also offer resonant subjects both for drawing and painting.

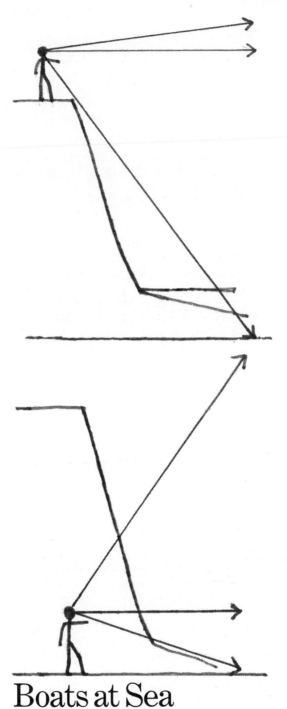

Boats at Sea

The vastness of the sea is difficult to portray in paint. It is better, when first tackling subjects like this, to take a portion of sea, study it thoroughly, make drawings and plan the angle and scale of your boat subject.

The position from which you paint in relation to the sea and horizon is most important. If you are on a cliff-top (high angle) the horizon will appear level with your eyes, in which case there will be a large expanse of sea or beach in the foreground with very little sky area; and of course you look down on to most of the boats.

If you are standing or sitting on the beach (low angle), then again the horizon will be level with your eye height but the sea will become more of a strip along the bottom of the painting and boats will present a side view with masts and superstructure silhouetted against a larger area of sky. The lower angle gives a more intimate and dramatic aspect to your painting whilst the high angle suggests a more remote and serene atmosphere. These generalisations should, however, only be considered as a rough guide to setting up your picture. Remember that a horizon across the middle of a painting is best avoided.

Try to emphasise the character of your chosen boat type by placing it in the appropriate setting and if possible under typical weather conditions. This is not always easy when the painting cannot be produced on the spot.

Stage 1

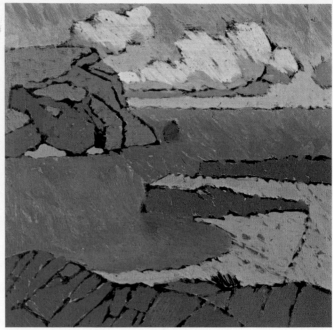

Stage 2

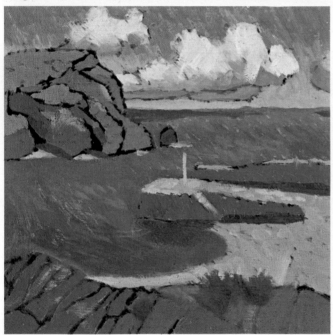

Stage 3

Harbour scene: demonstration

Size: 265 × 265 mm/10½ × 10½ in. Brushes: Nos. 2 and 5 hog-hair; Nos. 2 and rigger sable. Colours: cobalt blue, ultramarine, viridian, sap green, raw umber, Naples yellow, yellow ochre, cadmium red.

In this demonstration I am attempting to illustrate the points I have already described by drawing together many of the components that feature in and around harbours into a hypothetical subject.

Stage 1

Using a rich coloured ground to give warmth to a predominantly blue-green subject, I draw over it the main compositional forms.

Stage 2

Blocking in the main areas I keep the tones as close as possible to those of the finished painting I have in mind. I make the general colour of the sea echo that of the sky, allowing the red ground to glint through. This prevents the overall effect from becoming too cool.

Stage 3

At this point I consider the influence of the sky on the sea, and indicate the shadow of the clouds on the sea's surface, the indirect reflections on it of the light clouds and cliffs, and the direct reflection of the harbour wall in

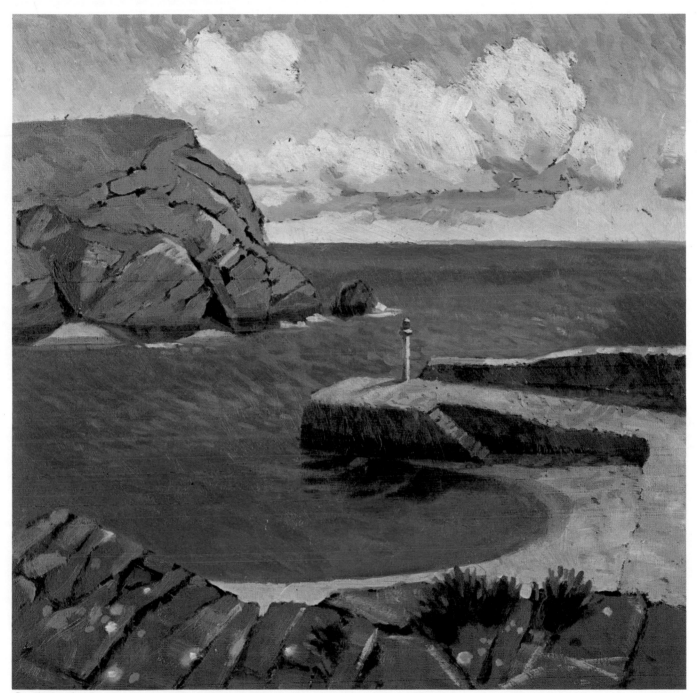

Stage 4 – the finished painting

the still water below it. Small plants in the foreground are then added to bring relief into the crags. I also put in the tide line on the harbour wall and the rocks where the seaweed clings to indicate that it is low tide.

Stage 4 – the finished painting

I now add the texture of the wind-ruffled water and the indirect cloud reflections more completely, and soften the cloud shadow. Notice how the sand under the very shallow water catches the sun, throwing up a clear, transparent blue green. Underwater rocks in this sandy bay are painted in with purple. I then modify the whole picture with touches of strong colour to help unify it and give the impression of an overall light source falling on all elements within the picture.

103

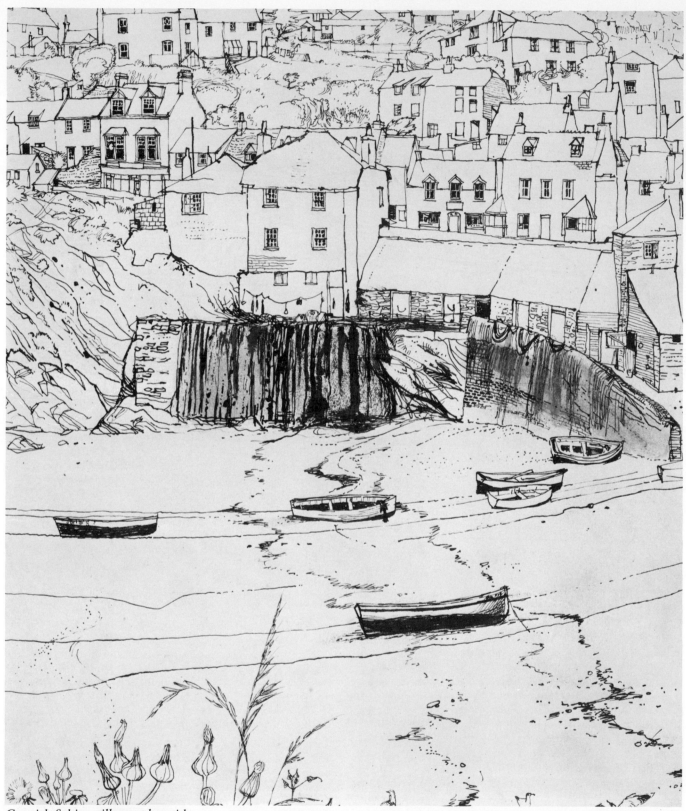

Cornish fishing village at low tide.

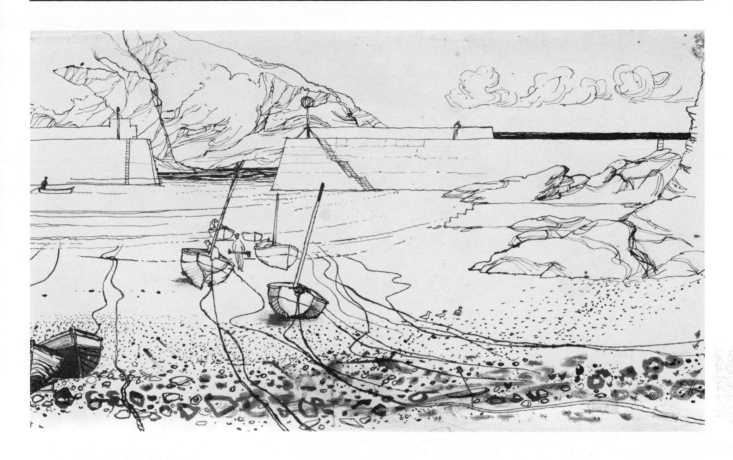

Painting the Sea

Consider the physical characteristics of sea, sky and land in their most basic form and look at their visual relationship to each other.

The sky influences both the sea and the land; shadows will be cast by any clouds that come between the sun and the surface of either sea or land. Land forms may be reflected in the sea in parts, and the sea in some areas will reflect the sky. This interaction means in practical terms that some sky colours will be found in the sea as will some land colours. The sky on the underside of clouds, on the other hand, will reflect something of the coolness of the sea colour where they are above it but over the land they will reflect the warmer land colours.

Notice how wind, and the resulting wave patterns formed, affect the tone and line of the sea, as does the seabed in shallower water. Boat hulls and sails reflected in the water's surface often show up almost to the same line: likewise bright light bouncing off the sea's surface affects the colour of harbour walls and ships.

Rogue Wave: demonstration

Size: 265 × 265 mm/10½ × 10½ in. Brushes: Nos. 2 and 5 hog-hair; Nos. 2 and rigger sable. Colours: cobalt blue, viridian, permanent blue, sap green, cadmium red, yellow ochre.

In this picture I am aiming to capture the nature of the hazards which fishing vessels undergo when working. To dramatise the subject I view it from the trough of a large wave that is pitching the boat headlong down it – into the picture, in fact. Such pictures can never be painted *in situ* – if you are brave enough to go out in such weather, the smallest of sketchbooks and perhaps a camera will help to capture for you the essentials, but these can only be realised in the studio. Just a few compositional lines on the back of an envelope gave me the inspiration for this painting.

Stage 1 (page 106)

I draw in the essential lines of the composition, making sure that the scale of the boat is correct in relation to the

Rogue wave demonstration

Stage 1

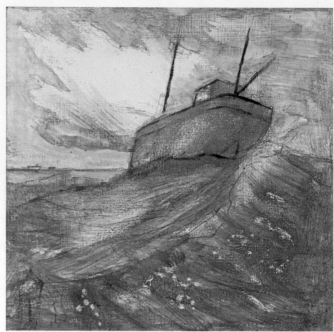

Stage 2

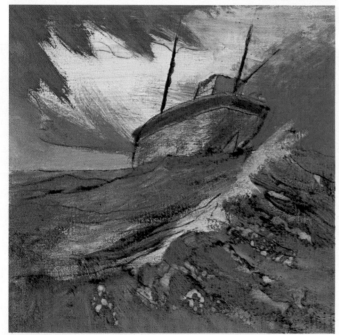

Stage 3

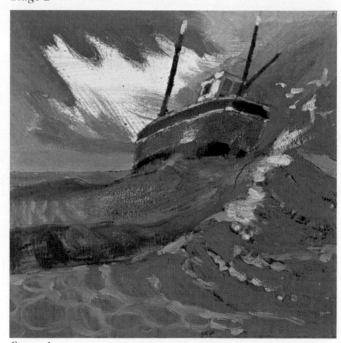

Stage 4

picture surface. These few lines dictate the drama and tension of the composition; once I have got them correct I can proceed with confidence.

Stage 2

As the lighting of the subject is the other essential ingredient in the composition, I work over it to enhance the dramatic effect started in Stage 1 with washes of thin permanent blue mixed with a little black.

Stage 3

I then add the basic subject colours to produce form and substance, light and atmosphere. For painting in the wave I use a dryish brush, dragging it over the underpainting and the ground to give a rough, broken texture.

Stage 4

To offset the overall coldness of the picture, I adjust the balance by painting in the brown of the hull and the dull reds of the rudder and the fishermen on deck. Foam trapped beneath the surface shows as a lighter green: I

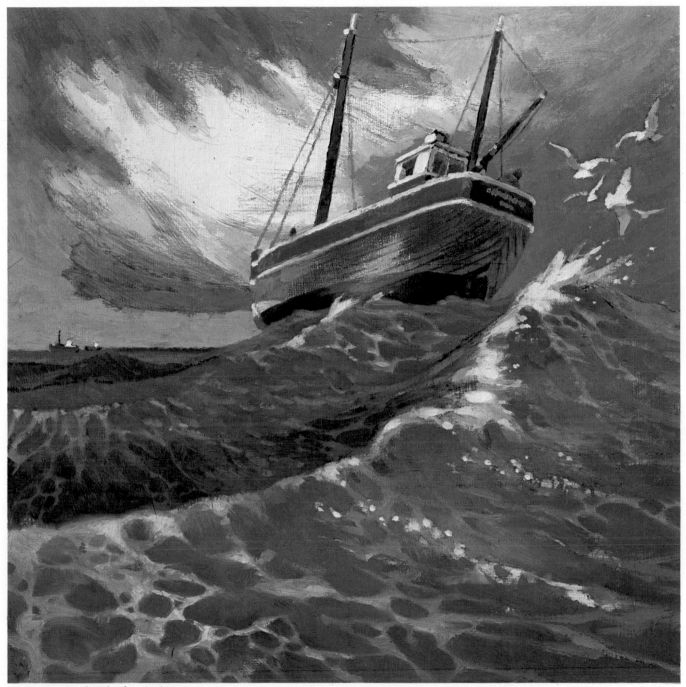

Stage 5 – the finished painting

paint this by putting in the actual lines of foam and, when it is virtually dry, painting into them the elliptical areas which are formed as the foam disperses. (You can see this happening from the stern of harbour and cross-channel ferries.)

Stage 5 – the finished painting

I finally add the details of the boat, the small ships on the horizon, the seagulls and the flying foam, which I apply quite drily and loosely. Notice how the undersection of the hull picks up the colour of the foaming sea.

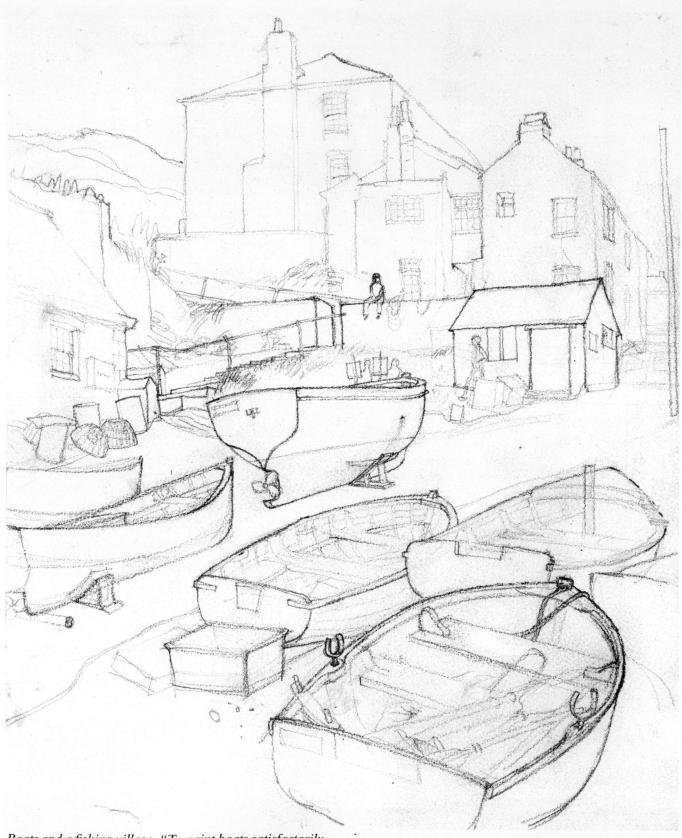

*Boats and a fishing village. "To paint boats satisfactorily
you need a basic knowledge of their form and function.
There is no better way of gaining this than by drawing
them at first hand." See page 100.*

Stage 1

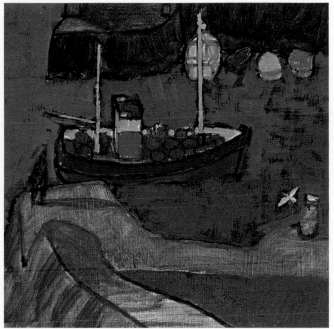

Stage 2

Returning with the Catch

In this painting I chose to present a completely different view-point to that of the previous one. Both depict fishing boats – almost identical in fact – but I felt it would be helpful to show two contrasting aspects by using a completely different angle, context and colour.

The previous painting was a seascape with the elements dominating, the boat tossing about on a heavy sea. In this painting (pages 109–11) all is serene. It is evening. The water is calm. The fishermen's job is nearly finished for the day and their craft is slipping into harbour laden with the day's catch.

The diagonal lines in the first work suggested action and movement, whereas in the painting the verticals and horizontals contrast with each other to give a stabilised static quality. The lines of the jetty in the foreground serve to lead one into the picture and are gentle in character.

In this picture there is no horizon and no sky, but the evening sun is evident on the harbour walls, in the boats, and in the long shadows thrown by them.

Evening light, because it is so ephemeral, is best recorded by making written colour notes on sketches and by your memorising as far as possible the qualities of light and the forms that shadows take on when under very low light angles. Photographs too can help.

Demonstration

Size: 265 × 265 mm/10½ × 10½ in. Brushes: Nos. 2 and 6 flat hog-hair; No. 4 flat sable, rigger. Colours: permanent blue, sap green, Naples yellow, cadmium yellow, cadmium red, raw sienna, raw umber, cobalt blue.

Stage 1 (above)

I quickly draw in the main subject forms in dark blue to capture the boat entering the harbour.

Stage 2

I now block in the general colours to create a warm evening glow, bearing in mind that certain areas will be picked out later in light warm colour where they catch the low evening sunlight. This means that most of the colour has to be rather rich and on the dark side.

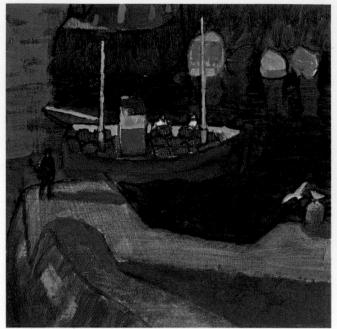

Stage 3

Stage 4

Stage 3

I refine the colours and tones, paying particular attention to reflections and texture; and then deepen the water in the shadow areas and add richer tones generally to give contrast to the highlights.

Stage 4

At this point texture and detail become very much more important but they must be seen in relation to the whole atmosphere and mood of the painting. Small patches of colour – such as distant figures, the small boats, and detail on the larger boat – must not jump out of context and I keep the overall colour largely warm in character.

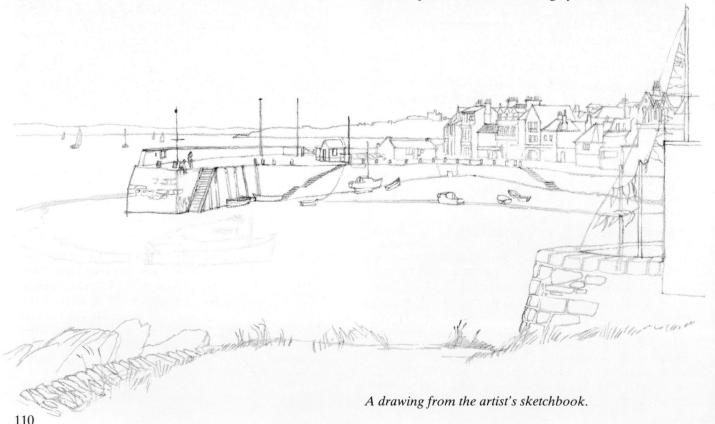

A drawing from the artist's sketchbook.

Returning with the Catch demonstration

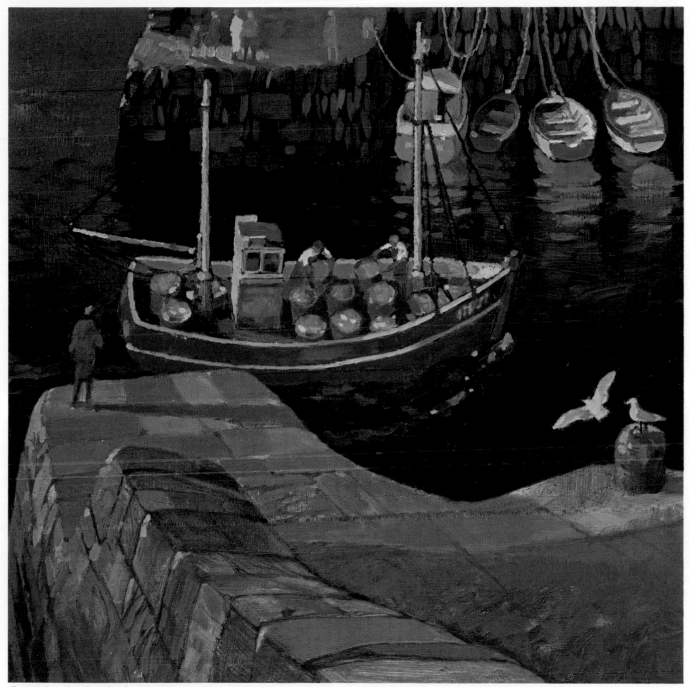

Stage 5 – the finished painting

Stage 5 – the finished painting

I then work over the picture to establish the various textures. The wall behind the boat, although strongly textured, has to remain generally quite dark. The foreground wall needs to give the impression of the waning sun falling on one side while at the same time shining obliquely across the flat surface which in turn reflects something of the unseen sky colour. The deep and dark quality of the water is built up with successive layers of transparent colour, mainly sap green mixed with a little raw umber and, in the later layers, with a little cobalt blue as well.

I keep as much colour in the shadows as possible otherwise they become sooty and dead and lose their luminosity. Never mix black with your base colour to produce a shadow colour. I keep shadow areas clean and luminous by increasing the intensity of the base colour with a small amount of its complementary or opposite colour – red to green, blue to orange, yellow to purple. Experiment with colour, using as little white and black as possible.

111

The Harbour at low tide

Nothing is more serene, to my mind, than the sight of a small fishing harbour at low tide, with the boats lying on their sides or propped against the harbour wall as if asleep. Pools of water left by the receding tide give dramatic yet subtle contrasts against wet sand or mud, gulls perch on stones and wade across the mud looking for food. Human activity is generally confined to repairs, painting boats, and preparations for the next incoming tide.

In previous demonstrations I have shown how bright sunlight, evening light, tide and sea have their effect on solids: the hull shapes, the cliffs, and man-made constructions such as harbour walls and jetties. In the next demonstration I attempt to show the underwater forms of stranded boats, and the effect of the bed of the harbour when left to dry out after the tide has receded.

Unless the wind is very strong, the shallow pools left by the tide have almost a mirror's surface, and so will reflect light from the sky or almost the very colour of objects that are near, though usually slightly darker. Wet mud and sand also pick up reflections, especially when viewed from ground level–a stretch of sand against strong sunlight can be almost dazzling, mud on a blue sunny day can pick up the azure of the sky, or retain some of the hull colour of a boat lying in it. When painting harbours at low tide look first for the tonal variations: this will help you to establish whether you have chosen the right viewpoint. Study the reflections, which will often break up what might appear first to be a series of dull, horizontal lines. In the studio, it is worthwhile practising reflections by using a model boat laid flat upon a mirror: that way one learns about basic principles and also about shadow formations as well. Remember not to confuse a reflection with a cast shadow.

Boats present different and exciting shapes when out of water and, seen from a low viewpoint when stranded or hauled out of the water for overhaul or storage, their shapes repay careful study, being essentially sculptural. Notice how the hulls vary according to their function: wide and shallow for inshore work or, as with sailing boats, with deep keels to stabilise them.

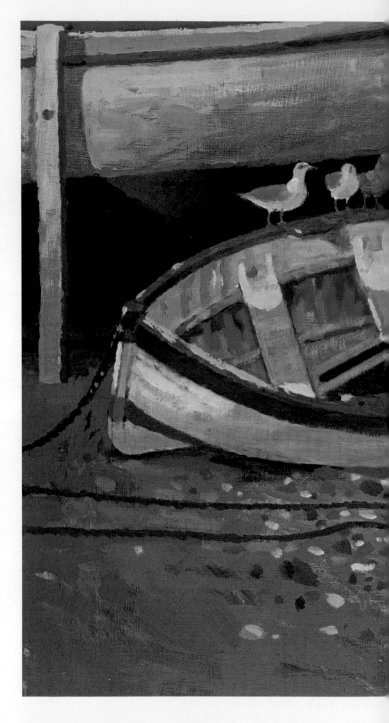

Demonstration painting

Size: 431 × 226 mm/15 × 10½ in. Brushes: Nos. 2, 5, 8 flat sable; No. 2 round sable. Colours: Raw sienna, raw umber, Indian red, cobalt blue, yellow ochre, sap green.

An approaching storm makes the sky darker than the sea, which picks up the light from overhead. Likewise, the pools at the harbour entrance reflect indirect light

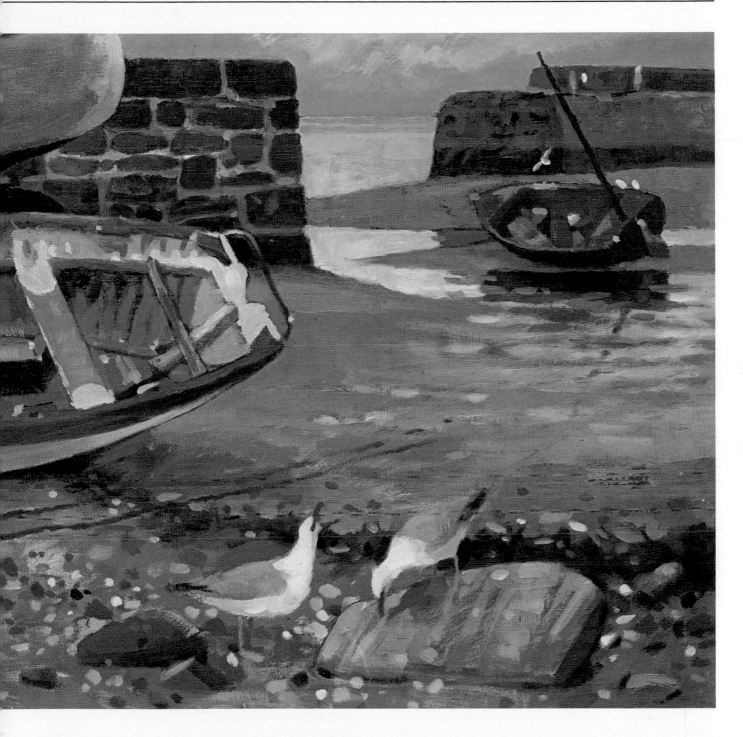

cloud colour. I paint the wet mud in a light tone, picking out the little pools between my viewpoint and the boat on the right in light touches of colour, making sure to capture the dark reflection from the boat – a tone darker than that of the hull itself. When painting the blue and white boat, I make sure to get the correct tonal values of the side that is lying down: notice how reflected light from the mud gives it a warm tone. In the foreground, I paint in rocks and small stones, and also a line of seaweed left by the tide which gives contrast to the mud. Notice how I observe the shadow of the leg holding up the keelboat (top left): this emphasises the hull shape,

giving it mass and form. Finally I paint in the gulls and the figures on the far quay, taking special care to make their respective sizes right, since they establish the size of the objects they are standing on, and create the correct sense of distance.

113

Pleasure and sailing boats

Whether we live inland or on the sea most of us have seen sailing dinghies and other sailcraft about on lakes, rivers and along the coast. Nowadays, their hulls are made of glass fibre which can be moulded in any colour: likewise sailmakers cut sails of material in many colours. The sight of such craft always gives me (and many people) the itch to paint them: they are one of the most popular of subjects with artists.

The beauty of line and form in most sailing craft is irresistible, but careful observation of proportion is vital. We tend to draw or paint what we expect to be the proportions but many craft do not conform to the popular conception of a sailing boat. Two triangles for sails are not always sufficient and the proportion of mast height to length of the hull can prove to be surprising.

The sails of most dinghies and cruisers can be extremely colourful, particularly the large balloon spinnaker sails, for they possess the quality of apparently holding the light. They usually reflect a lot of light from the sky and the sea and consequently close scrutiny is needed to check the extent to which coloured sails are affected by the water reflecting on to them.

Other craft such as the small motor cruisers taking visitors out to visit seal rocks or smugglers' coves can provide lively subjects, particularly if they are 'dressed overall' with small flags with the visitors themselves also providing a large share of the colour.

When painting sailing craft, work out the tonal scheme for your picture right from the start. For instance, if you wish to emphasise the sun striking the light sails, your sky and sea or whatever the background consists of must be dark enough to help the sails show up clearly. It can be exaggerated of course but beware of going too far or

you may give the painting a rather brash, vulgar look. On the other hand you may wish to keep the whole background light and silhouette the shape of the boats against this. Whichever scheme you wish to use, be positive about your picture and think it out a little beforehand, making small tonal sketches to work out your darks and lights.

As with all moving objects, sailboats do not compose themselves for your benefit: rarely do you see a satisfying composition for more than a few seconds, which only a camera or the briefest of sketches can record. Try and single out one or two boats at the most for your composition: a row of equally sized shapes can make for a dull picture. An amalgam of your sketches, drawn up carefully, together with colour notes, can provide you with a much more satisfactory picture to paint at home or in the studio.

Using photographs

As I have already pointed out, a camera is helpful in recording the moving aspects of marine subjects – sailboats and fishing vessels. But accessories too get moved about from one day to the next: a pile of lobster pots on a quay you see one evening will be gone the next day, nets likewise. This photograph has a linear quality that captures my imagination; I like the way the nets are draped. It was from such a photograph that once, on a very rainy day, I painted a 'composed' picture of freshly-caught mackerel.

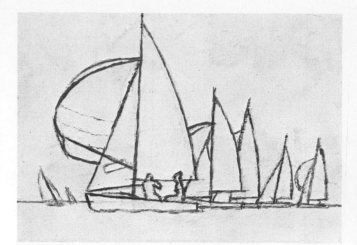
Stage 1

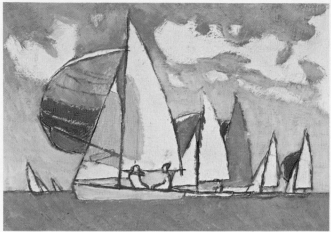
Stage 2

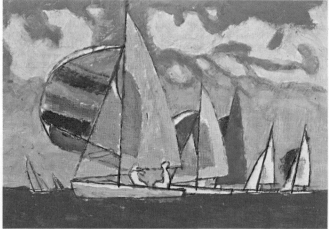
Stage 3

Stage 4

Dinghy racing: demonstration

Size: 266 × 193 mm/10½ × 7 in. Brushes: Nos. 2 and 6 flat hog-hair; No. 2 flat sable, rigger. Colours: cobalt blue, ultramarine, alizarin crimson, cadmium red, cadmium yellow, yellow ochre.

For this sailing race I decided to give the painting a light, sunny atmosphere but, in order to show the light in the sails, I had to make sure that the sky had virtually no white and instead quite a stong tone. The sails are not white as I wished them to appear lit by a warm sunlight. Although the sky changes colour from top to horizon it does not change tone appreciably. This gives a good tone background not only for the large sails but for the small distant craft on the left whose sails stand out brightly even though they are some way away.

Stage 1

I draw in the subject carefully, paying attention to proportion and avoiding confusing detail where possible, working from a series of preliminary sketches.

Stage 2

I relate the colour and some of the tonal qualities as soon as possible but keep the effect rather lighter than is going to be the case eventually. It is always possible to intensify and strengthen the colour later.

Stage 3

The sky needs to recede, so I brush in the clouds with a soft blue grey, increasing the strength of sky colour near the horizon and the colour on the sails, and darkening the water to achieve the final tonal quality for the whole painting.

Stage 4

I now put in more modelling in the clouds and strengthen the blue of the sky, taking account of the subtlety in the colour of sails, boat hulls and some reflections.

116

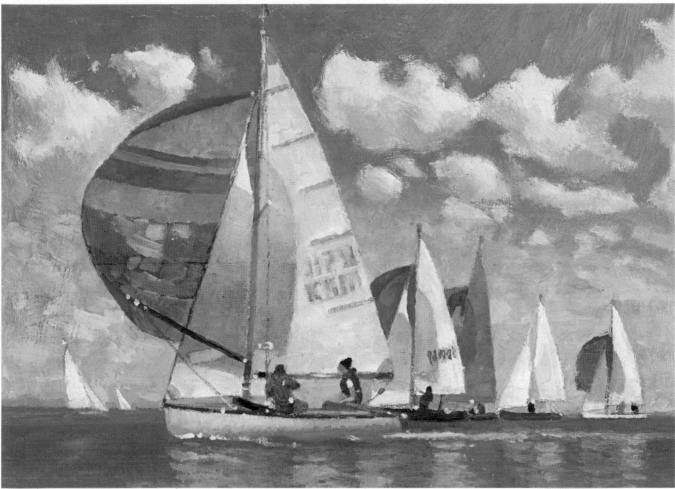

Stage 5 – the finished painting

Stage 5 – the finished painting

This is the point at which the whole painting needs to be balanced up. I lighten the sky and warm it up toward the right as the sun would be just outside the picture on this side. Not only is the sky lightened but a degree of 'warming-up' of the pale blue is necessary through the addition of a little Naples yellow.

I indicate detail, rather than actually paint it in, by the use of various small highlights and carefully placed spots of colour.

Note how I keep the reflections deliberately subdued, so as not to unbalance the picture. Nevertheless, there is a variety of colours in this calm sea to make it interesting.

Docks and Ports

As many of us live in cities I have included a dock scene. A busy port or dock area provides a wealth of material for the keen-eyed painter, and while there is usually a total absence of natural forms – the buildings, cranes, high quaysides; the bustle of containers and goods being loaded or unloaded onto lorries or railway trucks; and the massive curved shapes of cargo ships can offer subjects very different from the little fishing ports illustrated in previous demonstrations, but equally rewarding.

One of the first things one notices about any industrial area, compared with that of clean windswept coastal places, is that the light is almost always different in quality. Smoke and heat haze from towns and cities filters light in a way that can soften the overall colouring. This is not a disadvantage, for industrial machinery, warehouses, ships and dockside fitments are often painted in bright colours, and the atmosphere can have an effect in unifying a scene you might want to paint. I like particularly to contrast the sharp angles of cranes and warehouses with the massive curved bulk of cargo vessels.

Make sure when you start industrial dockside sketching or painting that you are not in a position that gets in the way of traffic or people's work. Often a good vantage for a picture turns out to be on private property: it is well to check with the office to obtain permission so that you are not interrupted!

When you have chosen your site, you will probably find that what you can see in front of you has too much material in it: containers may be stacked obscuring part of a ship, a lorry may be too prominent in the foreground. Walk about before settling down, making quick sketches of parts of your subject. Above all, pay attention to the scale of your picture and decide out of the many objects there which ones you wish to be the focus of attention: there is nothing wrong in making the side of a warehouse or the sern of a cargo vessel occupy a large part of your canvas so long as it serves your composition and is interesting in itself. Your preliminary sketches will help you here. Remember that, in subjects such as dock scenes, too much detail can make your final picture look fussy and over-worked: be selective. But do try to include people for they immediately give the sense of scale to your subject.

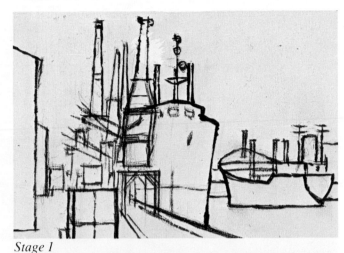
Stage 1

Dock scene: demonstration

Size: 265 × 190 mm/10½ × 7½ in. Brushes: Nos. 2 and 6 hog-hair; No. 2 flat sable, rigger. Colours: cobalt blue, ultramarine, sap green, Naples yellow, yellow ochre, raw umber, raw sienna, cadmium orange.

An overcast sky further darkened with industrial smoke set the tone for this dock scene. Nevertheless there is enough shape and exciting colour in the subject for me to want to paint it. Before starting, I walk about the quayside and make several sketches, before choosing this particular viewpoint. I then find I have to rearrange the large crate in the foreground so that it balances my composition more satisfactorily.

When you tackle an industrial scene such as this, establish the main forms of your composition before you add any detail. Check on your perspective – with all the flat and vertical planes one finds here, an inaccurate line to your vanishing point will soon show up!

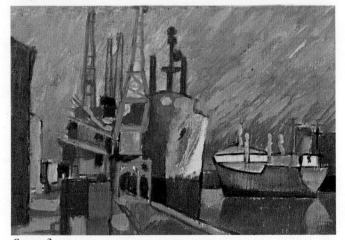
Stage 3

Stage 1

After selecting my viewpoint from preliminary sketches I draw in carefully the main outlines, making sure that the perspective lines of the dockside are in accordance with the vanishing point (just above and to the left of the foreground crate). Throughout the painting of this picture I constantly refer to my sketches.

Stage 2

I block in the main tones of the picture, keeping the colours muted at this stage. I establish the colour and tone of the sky, for this gives the key to the overall effect I have in mind for the finished picture.

Stage 2

119

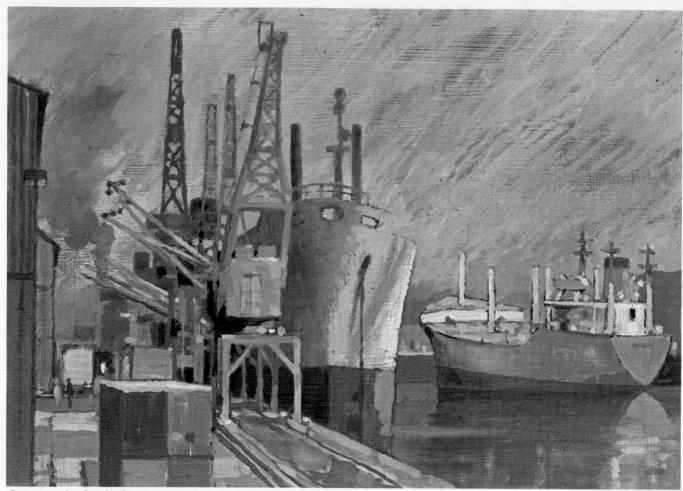

Stage 4 – the finished painting

Stage 3 (page 119)

Still keeping the painting loose within the guidelines established in Stage 1, I gradually work in the detail and smaller forms. (A brilliant yellow forklift truck parked itself at this point in the foreground: I consider for a moment adding it in but decide that it unbalances the colour composition.)

Stage 4 – the finished painting

At this stage I have to consider just how much detail – of rigging, cranes, lorries and people – I should add without destroying the overall unity of the picture. The reflections of the right-hand vessel are put in (or taken out of wet paint so that the ground showed through). The warmest hue in the picture is the orange funnel and, beneath it, is the centre of the picture's focus. Once I have established this focal point I can choose how much detail to put in below.

A fitful sun was shining dully through the haze, just enough to be caught by the ships' superstructure and hull and also on the sharp edges of the crane in the foreground.

A few figures on the quayside on the left of the picture are suggested with a couple of simple brush strokes in order to provide the overall scale of the subject.

120

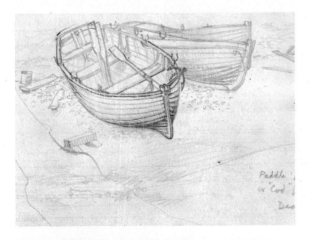

Details of boats and accessories

Nets, floats, lobster pots, boxes, baskets, markers, buoys, chains, anchors, propellers, ropes, blocks and tackle, lights, lifebelts and many more such objects are to be found on or attached to boats or in the vicinity of harbours.

Their variety, surface quality, and basic functional purpose make them fascinating to observe, draw and paint; while they are always useful too as foreground material – a form of still life – in larger pictures.

The effect of sea water, weather and usage tends to add to the visual quality of these objects rather than destroying it. Even when discarded and decaying they exhibit qualities which the boat and harbour painter can put to good use.

Drawing these items can be difficult and exacting, but rewarding if you are going to paint them subsequently. Drawing is the best means of simplifying and finding out how these items function or are put together.

'Stalk' your object – walk around it; handle it and observe it from as many angles as possible before drawing it. Use your drawing ability to clarify and to define its function so that when you come to paint it you understand what you are drawing.

As in many boat details such as rigging, nets, rope, and other linear objects it is necessary to paint these using a rigger or fine, round sectioned sable brush. However, the result can often look hard or fussy and out of scale with the rest of the painting. There are two good ways to combat this. One is to avoid using too dark a tone on these details. The other is to paint the lines rather thicker than finally required and then paint back the background between the lines using a similar brush to the rest of the painting, slightly cutting back or overlapping the lines. This method relates the line work to the general scale of the other brush work and gives a looser effect.

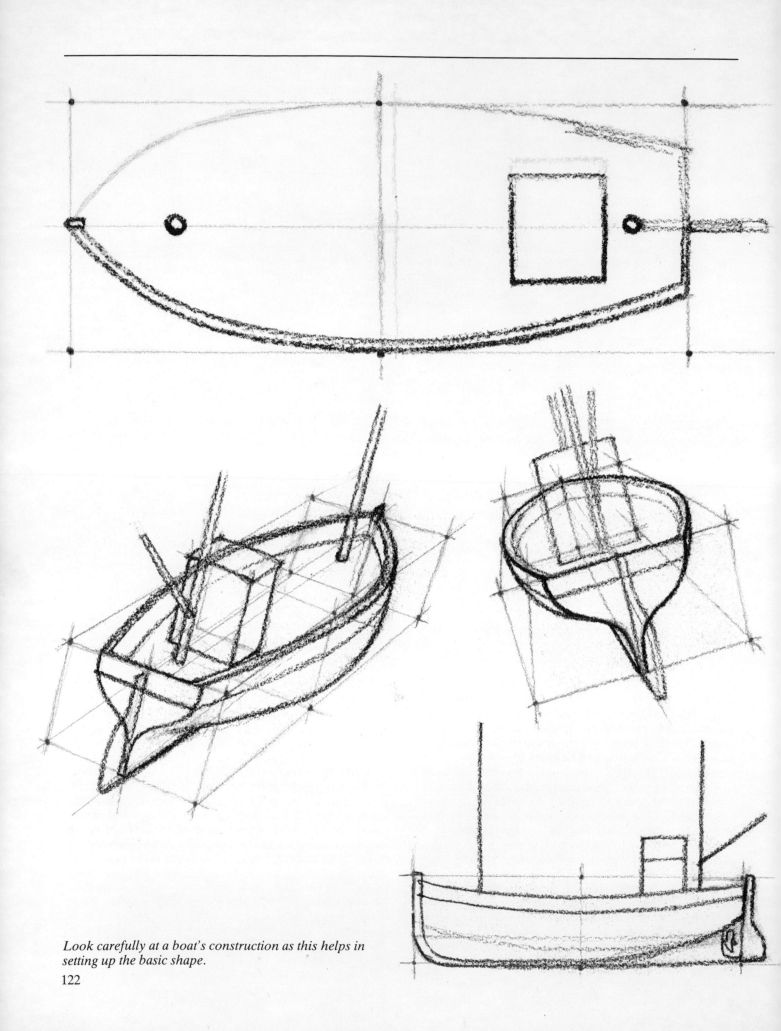

Look carefully at a boat's construction as this helps in setting up the basic shape.

122

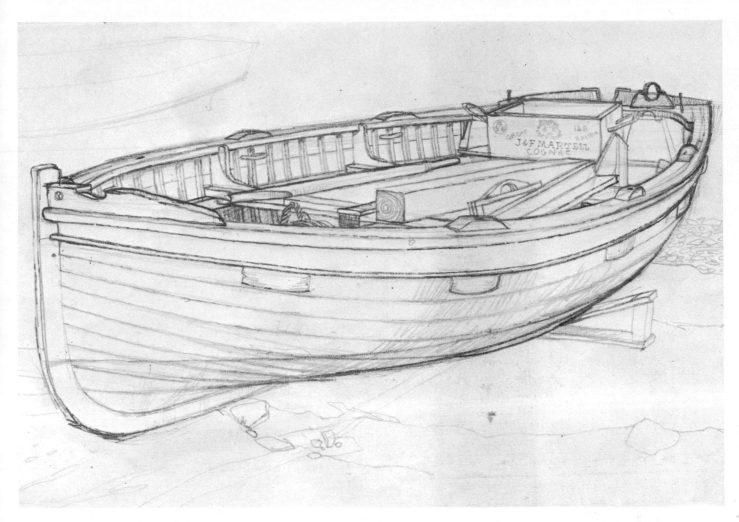

Structural Boat
Drawing

Apart from racing sailboats, it is unusual to find two boats of similar shape and size. Boats are built to suit the work they do, and when looked at are never arranged like matches in a match box. Even when you are drawing or painting boats in the water, a knowledge of their total structure, including that part hidden by the water, is an advantage. It is appropriate to end this chapter with a few pointers on looking at boat forms from different angles, and on how best to go about drawing them.

Boat hulks, as I have said, are very sculptural, and if you imagine them, not as constructed out of bent planks but as the whole boat carved from a solid block of material, then you will understand my approach.

Visualise the boat you wish to draw or paint as first having been in the form of a brick, or large baulk of timber. By 'seeing' this rectangular shape first, you will naturally draw it in perspective as you would a house or building. Very lightly draw in the appropriate 'box' for your first boat, making sure your perspective lines are consistent with your overall picture. If your boat is

tilted, or lying on its side, then your 'box' should take up the same angle. Similarly, if you are viewing your boat from the stern, or three-quarters on, so your 'box' must take on the same viewpoint. Now, by drawing your boat within the 'box', you can 'carve' it down by seeing the lines, bulk and shape. Where inward curves show up, so the 'box' is cut away: in other places, the sides of the boat and the keel will touch the outer sides, top, bottom and ends of your 'box'. On this page and opposite are simple outline drawings of a typical small fishing boat drawn from four different viewpoints: plan, elevation, stern on, and three-quarters stern on. Notice how perspective plays an essential part of the construction in the two on the right.

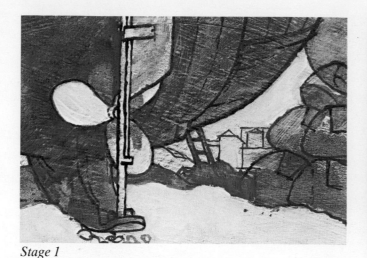

Stage 1

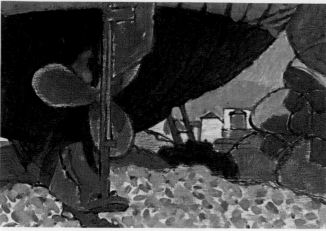

Stage 2

On the Beach: demonstration

Size: 265 × 190 mm/10½ × 7½ in. Brushes: Nos. 2 and 6 flat hog-hair; No. 4 sable, rigger. Colours: raw sienna, raw umber, Indian red, cobalt blue, cadmium red, yellow ochre, Naples yellow.

When painting a subject composed of details such as these, do consider the colour and tone of the individual elements in relation to the background. Are they lighter, warmer, cooler, darker? Do their shapes contrast interestingly with each other and with the background of larger forms? Avoid including too many objects which might cancel out each others' qualities. Better to concentrate on two or three details which have visual characteristics different from each other. The firm clean roundness of propeller blades against the angularity and roughness of the rudder and the more delicate net-like quality of the lobster pots gave me such a subject: simple in composition yet interesting in scale and detail. I have also contrasted scale, e.g. the houses behind the beach are smaller in the picture than the propeller and lobster pots, and are dwarfed by the mass of the boat's stern.

Stage 1

As this composition is so dependent on tonal relationships – the dark mass of the boat, the lightness of the beach texture and the light on the buildings – I indicate a rough approximation in tone at the same time as the drawing in.

Stage 2

Keeping the shadow areas rich and colourful is important, and for this I have to work out the quality of the light. As the boat itself varies from black underside to blue painted boards on the sides it was a little com-

plicated. However, notice that there is a lot of warm reflected light coming up from the light pebbles on the beach. This gives the underside a dark brown glow even on the black of the underwater area of the hull and also warms up the blue of the other boarding.

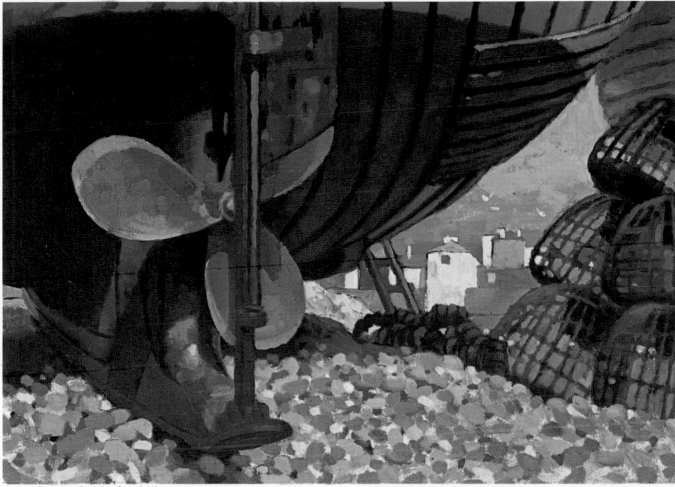

Stage 3 – the finished painting

Stage 3 – the finished painting

I have gone for the surface qualities of the various objects: the smooth sculptural form of the propeller, the rich dark tones of the stern of the boat and the light striking the distant houses, and the texture of the pebbles on the beach. To keep the beach light I only indicate deep shadow between occasional pebbles. This was a sufficient clue to keep the beach texture strong but essentially light in tone.

It is appropriate to end this chapter, and this book, with a drawing – one, from Clifford Bayly's sketchbook, of a fishing village seen from the seashore. All the artists in this book have reiterated their advice that the aspirant painter should draw as often as possible, carry a sketchbook constantly, and, in the case of outdoor subjects, do plenty of drawing in situ, both for its own sake and for developing later into paintings in the studio. To demonstrate the importance of this they offered the contents of their sketchbooks to be reproduced alongside their commentary and demonstrations. Their hope is that you the reader, will be keeping your own sketchbooks and constantly adding to them. As Peter Gilman wrote, "draw as often as you can, for the practice of co-ordinating hand with eye will undoubtedly improve your painting technique."

Index